Crusoe, the Worldly Wiener Dog

"Yeah, life is ruff."

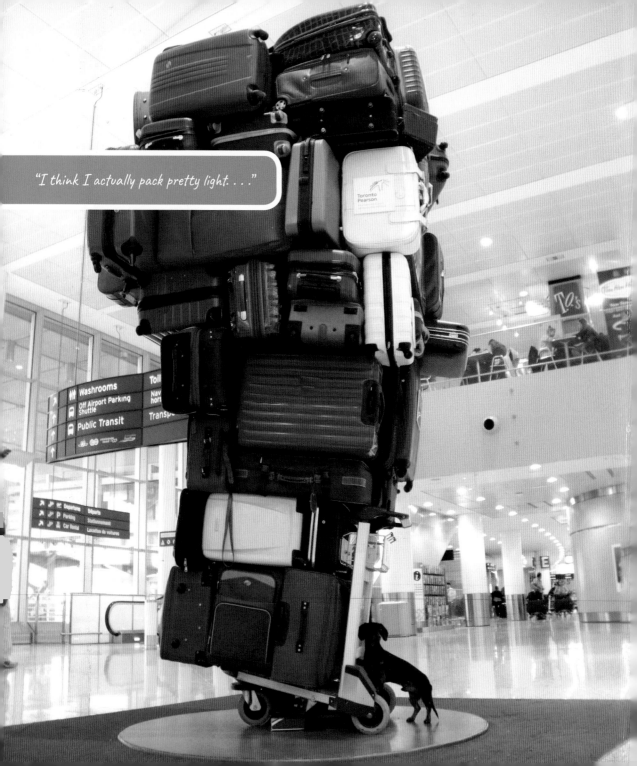

"I think I actually pack pretty light. . . ."

This is where I would queue a tacky rap song with such lyrical anecdotes as, "we made it," "look where I am," "started from the bottom now we're here," *"who-who-who let the dogs out?!" "mambo number 5!"*—sorry, got carried away at the end there—I do love a good beat!

Life hasn't been all stinky socks and toilet water, though. About a year after my first book came out, I had emergency surgery on my spine. You can imagine what a hit that was to my unshakeable ego. As if that wasn't enough, during my recovery I also lost someone close to me.

I have titled this book, "the worldly wiener dog," obviously because of my travels, but in a deeper sense as well. My travels, adventures, and hardships have enlightened me to a different way of seeing things. Money and fame may be the shiniest stones in the mountain stream, but health and happiness are the most precious.

I ended my last book with the words, *keep ballin',* which is now how I begin this one.

 Crusoe

Well, well, hello again.

It's me, Crusoe—can we say, *official*?—celebrity dachshund. I began my career as "the wiener dog who thinks he's more of a celebrity than he really is," and today most would agree I've finally reached the luminary levels my imagination once aspired to. Yet, it

seems as soon as I stand upon the summit of my achievements, a new peak appears with even taller ambitions of grandeur and break-the-internet heights of fame.

At the time of my last book 21 dog years ago, I was merely a wanting little pup who had only just dipped his paws in the puddle of fame, who had only a single cabinet of outfits, and who had only a couple of odd stamps in his passport. Compare that to now, and I am soaking in the tub of superstardom, sipping on the most expensive bottled toilet water Mum and Dad can afford, and where I once only had a chair to ponder the mysteries of the universe, I now have a whole room, complete with walk-in wardrobe, framed fan art and magazine covers on my wall, and a corner of the carpet to pee on.

Plus, the laundry room is right next to mine so anytime I want a stinky sock to chew on, I just take one.

Furthermore, I've become a frequent flyer, traveling across North America on tour, sampling cheese from Paris, exploring my heritage in Germany, hiking up ancient temples in Mexico, and so much more. I've graced countless TV interviews with my presence; I have over a *frickin' billion* video views to my name; I'm supposedly a bestselling author; and I can no longer safely geotag my location on an Instagram picture because PEOPLE WILL SHOW UP!

Introduction

Contents

LIFE AT HOME

PAGE 14

NEW YORK

PAGE 6

CALIFORNIA

PAGE 28

GRINDELWALD

SWITZERLAND

PAGE 22

TULUM — MEXICO

PAGE 40

OXFORD COUNTY — ON THE FARM — ONTARIO

0123

PAGE 52

0123

BRITISH COLUMBIA, CANADA

VANCOUVER

PAGE 58

ARRIVA

HARTSFIELD–JACKSON ATLANTA INTERNATIONAL AIRPORT

PAGE 63

ATLANTA

USA

ABCD

0173

DINNER AND A MOVIE

PAGE 66

8:00 PM

PARIS, FRANCE

PAGE 74

PAGE 80

DINOSAUR PARK

ALBERTA

PAGE 88

CINQUE TERRE
ITALY

PAGE 96

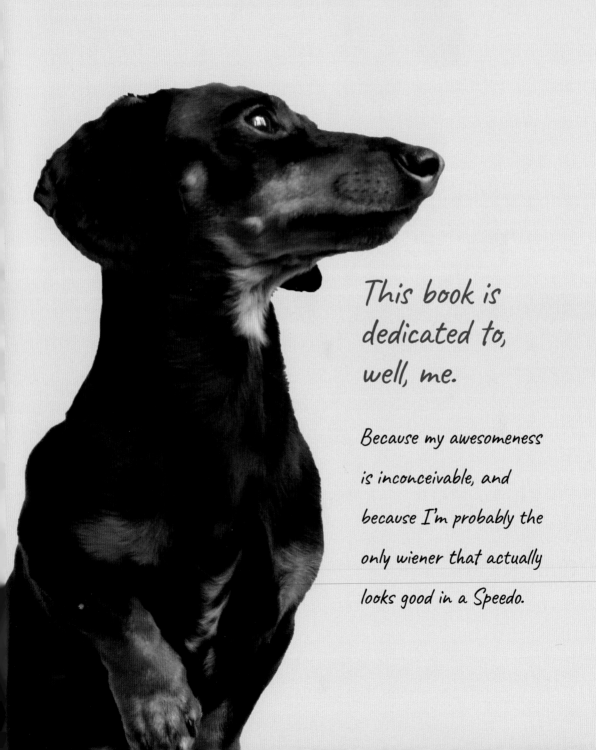

This book is
dedicated to,
well, me.

Because my awesomeness
is inconceivable, and
because I'm probably the
only wiener that actually
looks good in a Speedo.

CRUSOE, THE WORLDLY WIENER DOG. Copyright © 2018 by Ryan Beauchesne. All rights reserved. Printed in China. For information, address St. Martin's Press, 175 Fifth Avenue, New York, N.Y. 10010.

www.stmartins.com

Library of Congress Cataloging-in-Publication Data

Names: Beauchesne, Ryan, author.
Title: Crusoe, the worldly wiener dog : further adventures with the celebrity dachshund / Ryan Beauchesne.
Description: First edition. | New York : St. Martin's Griffin, 2018.
Identifiers: LCCN 2018017181 | ISBN 9781250134721 (paper over board) | ISBN 9781250134738 (ebook)
Subjects: LCSH: Miniature dachshunds—Canada—Biography. | Miniature dachshunds—Anecdotes. | Human-animal relationships.
Classification: LCC SF429.M52 B45 2018 | DDC 636.76—dc23
LC record available at https://lccn.loc.gov/2018017181

Our books may be purchased in bulk for promotional, educational, or business use. Please contact your local bookseller or the Macmillan Corporate and Premium Sales Department at 1-800-221-7945, extension 5442, or by email at MacmillanSpecialMarkets@macmillan.com.

First Edition: November 2018

10 9 8 7 6 5 4 3 2 1

CRUSOE

The Worldly Wiener Dog

Further Adventures with the Celebrity Dachshund

Ryan Beauchesne

ST. MARTIN'S GRIFFIN ❧ NEW YORK

Also by Ryan Beauchesne

Crusoe, the Celebrity Dachshund:

Adventures of the Wiener Dog Extraordinaire

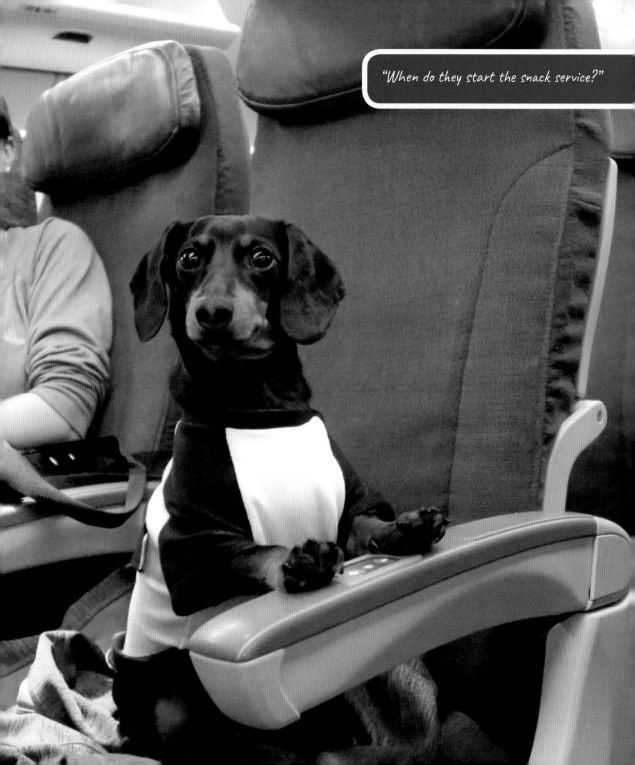

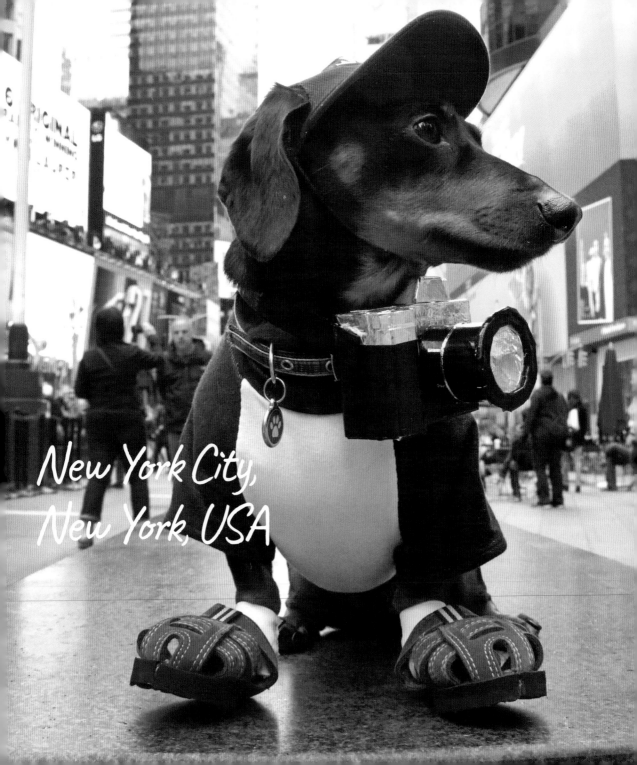

New York City,
New York, USA

New York was the first real "big city" I had ever been to, and it was unlike anything I'd ever experienced. I'll admit, I wasn't a huge fan at first—in fact, I really didn't like it, but New York is one city that seems to keep calling me back, and every new visit I make reveals a little more of its impressively unique character.

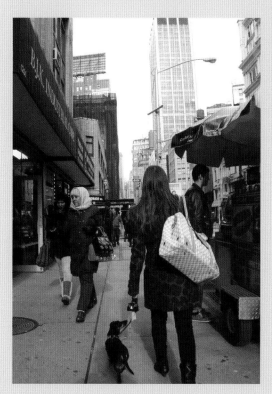

New York can easily overwhelm you with all the people, smells, and loud noises. It's a world where, *for once,* I feel "small." No one seems to notice the little hot dog darting between the feet of the crowd trying not to get stepped on.

Yet, as soon as someone yells *"hot dogs for sale!"* THEN OH—everybody notices!

Isn't this city supposed to be called the Big Apple? Where are all the heckin' fruit stands?

The most challenging part of New York is all the concrete. Being a country dog at heart, I still to this day cannot pee on concrete, and it was only very recently that I said **** *it* and began taking dumps on sidewalks. That took a lot of willpower, let me tell you, but once you're able

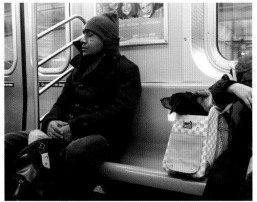

to just pop-a-squat mid-stroll on your way to the park, it changes you. All the previous insecurities you had in life just go out the window (*down the toilet?*).

Mum and Dad took me onto the subway for my first time, where dogs are allowed if kept in a bag. I was a little skeptical as you can tell.

I would have preferred a private limo or something, but as Mum so blatantly told me after I said I didn't want to ride with the common folk, "Crusoe, *we are* common folk!"

I disagreed, but I felt it would be awkward to cause a scene in front of all the people I would be complaining about.

I figured the best way to get over it would be to strike up a conversation with a fellow passenger, you know, to engage with my fellow peoples; to get on their level. Plus, if I ever decide to pursue a career in politics, I'll be able to better appeal to the middle class by promoting the fact I once rode the subway.

"Excuse me, fellow rider of the underground public transportation system. Beautiful tunnel today, isn't it? Sorry to disturb your nap, but I couldn't help wonder what that wonderful aroma is coming from your paper bag?"

The guy looked at me straight and said, *"It's a hot dog,"* and then gave me a creepy wink. My eyes widened in terrified shock! I quickly said "Oh" and turned away.

I knew I was right to be skeptical of

Ryan Beauchesne

BATDOG

Due to a recent uptick in the city's crime rate, BATDOG is unable to service all the general public and will now refocus his area of law enforcement on bylaw infractions by hot dog carts.

9

the subway, and I knew these people were not to be trusted!

I made sure to watch him out of the corner of my eye for the rest of the ride. I had to admit though, I was shocked to look at my watch and see how quickly we'd arrived at our destination.

My accommodation was much more in line with my *perceived* stature; the corner room of the tallest hotel *in all of North America,* with a perfect view out over the entire Central Park? The things you get to enjoy for free when you're a celebrity . . .

"You spoil us, Crusoe . . ." Mum said while admiring the view.

I've even come to learn that it's not all just concrete here. A little squirrel-watching from a Central Park bench is a lovely way to spend a couple of hours.

Even strutting down Wall Street, dressed in my best suit and briefcase, no one noticed me. Although, perhaps as a wiener in a suit I blended in more than I knew?

I'd be lying if I said I wasn't just a little bit resentful of how much harder it is to be noticed in this city. Then again, as Dad says, it's a healthy reality check for my ego to come here once in a while.

However, my most recent trip to New York City had quite an opposite effect.

We had come back to the city to attend the Shorty Awards ceremony, an award show for digital influencers, and supposedly I am quite "influential." *Ahem*

I arrived at the show and found myself walking the ~~red~~ teal carpet next to the

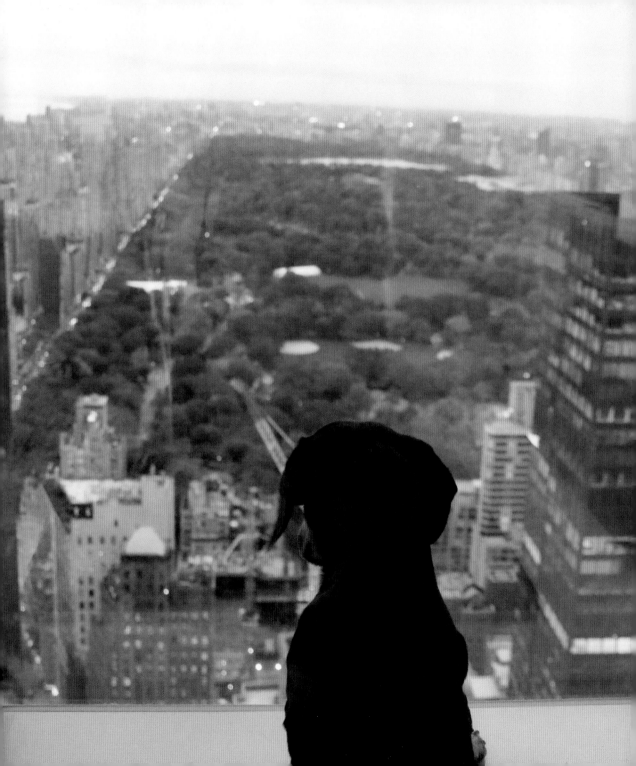

"My very first book signing was in New York City! When I first saw the cops, I was about to make a break for it out the back door, but turns out they just wanted to get my pawtograph! *Phew*"

likes of Bill Nye and Karlie Kloss and other television stars. I wasn't really surprised when the photographers asked Dad to hold me up and away for a clearer photo of me.

However, Dad being caught up in the moment, didn't realize he was being *framed out of the photos,* and was comically still smiling like a doofus for the cameras.

Poor guy. I wondered if I should tell him, but I figured I'd let him enjoy the moment.

Once we were seated at our dinner table, the announcer began the reveal for the "Best Animal" category. Our hearts nearly stopped . . . ***"And the winner is . . . Crusoe the Celebrity Dachshund!"***

We couldn't believe it! We raced on stage, Mum holding me in her arms, Dad scrambling to remember his speech. "Don't screw it up, Dad!" I whispered.

I also couldn't help but realize, once back in our hotel room, that the "Shorty" Award is taller than I am. I'm not sure, but I feel like that must mean something. . . .

I wonder if people will recognize me in the streets now? I guess we'll see, but for now this city has me feelin' tall.

Keep winnin',
Crusoe

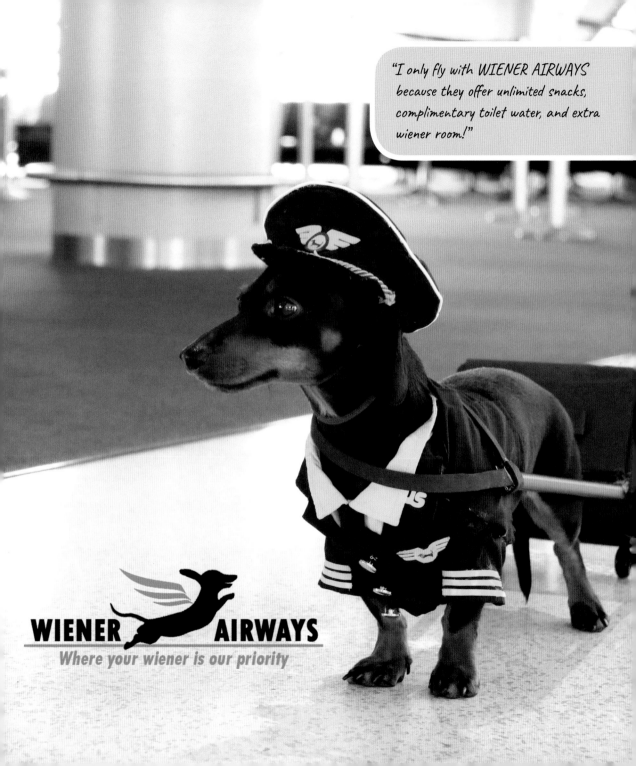

Life at Home

I might be a superstar of the digital world, but at home I live a pretty regular, low-key, even modest, type of life near Ottawa, Ontario.

In fact, when our harsh Canadian winter is almost upon us, it's not unheard of that I'll start burning furniture because Dad is too cheap to turn on the heat just yet.

I also do more chores than I should.

Like, I am way too famous to be seen meandering about a third-rate grocery store trying to find whatever the heck *"two bunches of radicchio"* is?! How about *two bunches of this is ridiculous!*

Plus, I always get recognized by people and then am forced to make awkward small talk about all the bananas in my cart.

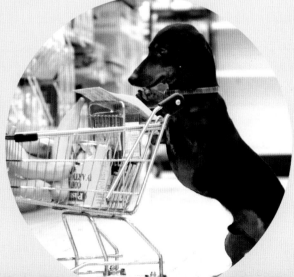

Dad also says that if I want to stay warm during winter, I need to help him collect firewood.

He cuts the big logs, and I cut the small ones into kindling (chew sticks).

In fact, sometimes after several days of lumberjackin' it with Dad, I find I've grown a full man-beard! This is what hard work will do to you, kids!

Despite being very accustomed to big cities and bright lights, I'm a country dog at heart, and often escape to my weekend chalet up north in Quebec for some fun in the wilderness, like ice

fishing or hunting for the infamous Sasquirrel (a cross between Sasquatch and squirrel). I've never seen one, but I see the tracks like *all the time.*

Every spring I help my Cousin Charles with the maple syrup production. My job is to sit in the bucket and make sure no thieves come around (hey, maple syrup is cutthroat business up here).

I'm usually shrunken and shriveled by the time morning comes around on those cold nights, but it's worth it for all the maple syrup I can eat!

As a Canadian pup, I'm very tolerant of the cold, and love playing in the snow.

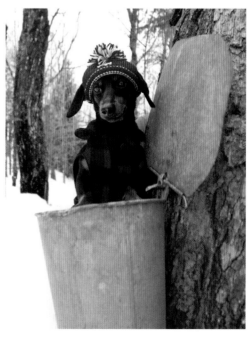

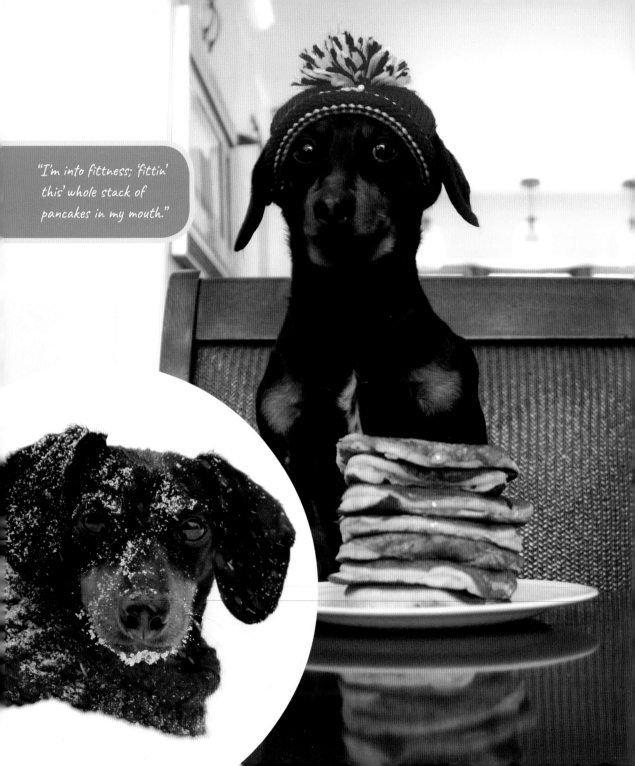

"I'm into fittness; 'fittin' this' whole stack of pancakes in my mouth."

The extra-cold weather up here makes sitting by a fire *extra*-satisfying. Not to mention if you have your favorite ferret with you!

Spending time at my chalet is also nice because I get to visit my longtime friend and mother-figure Laffie. She's older now, but we still lead some great expeditions together. It's nice knowing she always has my back, too.

"Wait a second," I said, halting her in her tracks while out on a wintery walk one day. "Look up ahead, I think—*could it be?* It must be a Sasquirrel!"

Keep runnin',
Crusoe

"And look, there's tracks leading right up behind me! It must have been following me this whole time!"

"Anyone who's never tried a real Quebec poutine has no idea what they're missing (including a couple pounds)."

"Winter isn't so bad when you're dressed for it!"

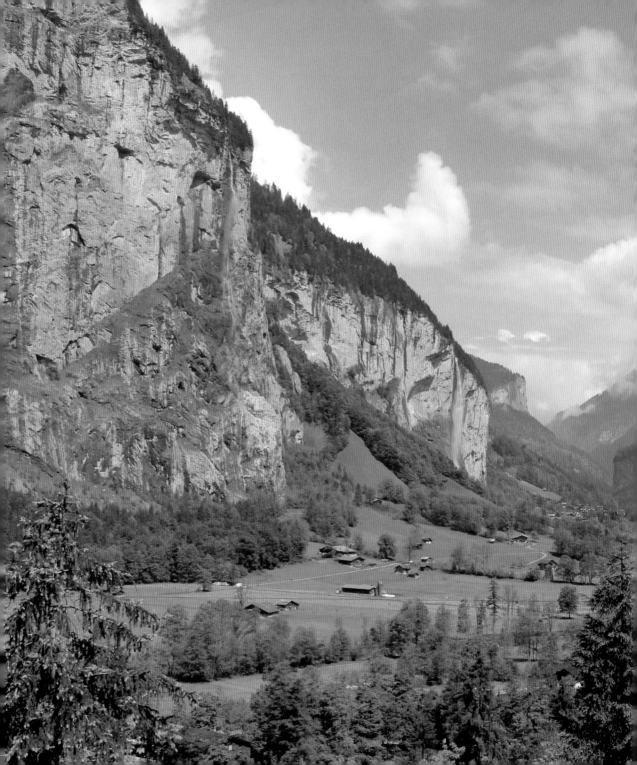

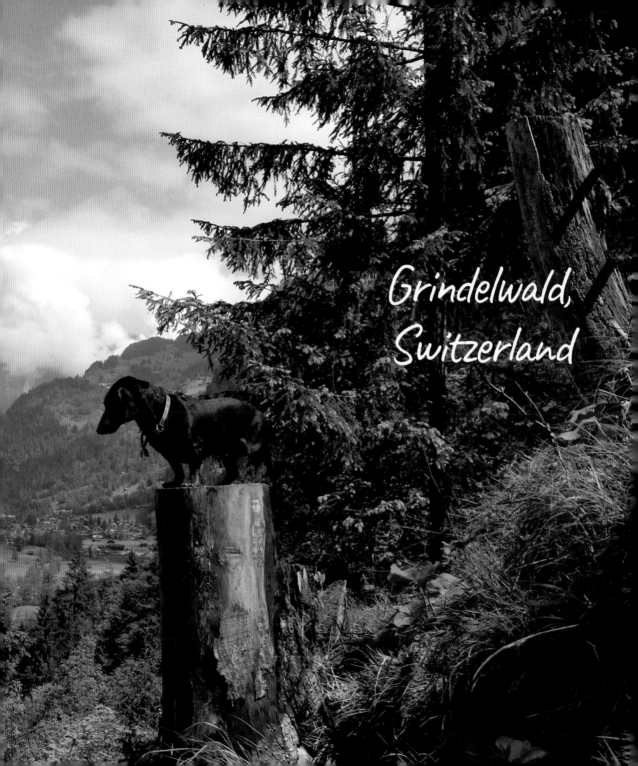

Grindelwald,
Switzerland

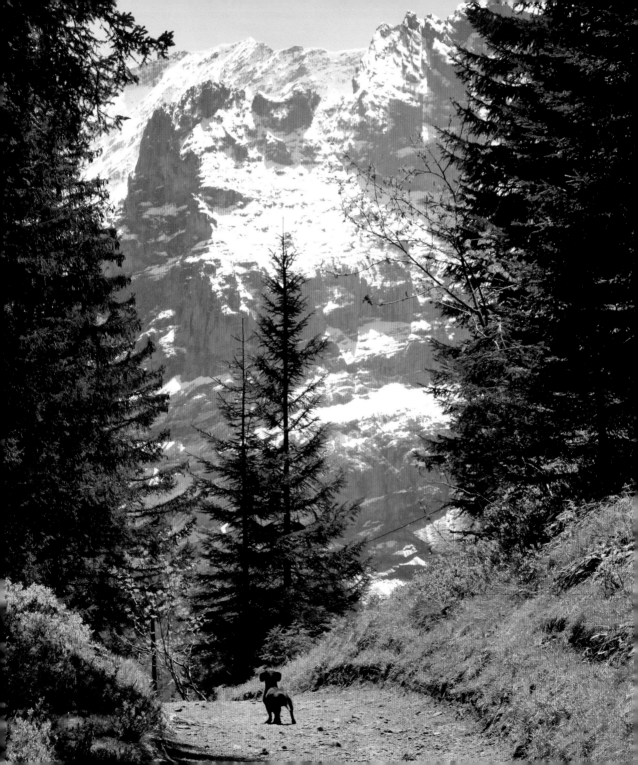

I was udderly excited to visit Grindelwald, a region of Switzerland that feels so truly magical it's like something out of another world. Sitting on that stump, I looked out over the Valley of 72 Waterfalls. Plummeting over those cliffs are breathtaking waterfalls, cascading down into nothing more than mist.

I guess it's no coincidence that this place was the inspiration for J. R. R. Tolkien's Elvish city of "Rivendell" in *The Lord of the Rings.*

We spent much of our time hiking among the Alps, enjoying the fresh mountain air and gorgeous scenery. As always, I led the adventure, barely staying in sight of the group.

We often paused to admire the grazing cows in the mountain meadows. For the same reason as the cows wear them, Mum fitted me with a little bell so she could always hear where I was as I tromped freely and happily about.

However, the cows were a lot less endearing when they were blocking our passage along the road, shooting me sinister looks. Seriously! Dad even had to carry me while near them because they would become agitated seeing me walk about.

(I know I can cast a rather intimidating figure.)

We made it through unscathed, and as we climbed higher in the mountains I was delighted to see something I recognized—snow! I had figuratively felt on top of the world many times before, but this was something else.

As we hiked our way back down, the humans

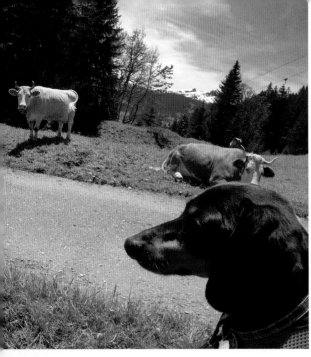

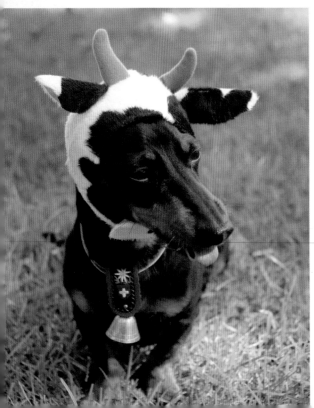

incessantly complaining about their knees, Dad explained to me how the Swiss people consume the most cheese per capita, and that's what all the cows are for.

"Cheese?! Well, why didn't you say so!" So, I devised a clever disguise to infiltrate the herd, my mission being to find out where they keep the cheese and make off with as much of it as it as I could.

I made my approach, slow and lumbering while munching grass so as to blend in with the other cows. I was almost upon the herd when my stupid hat fell off and one of them spotted me. She came bounding toward me at full speed! I would have s*** my pants if I were wearing some, but luckily Dad swept in at the last minute to save me. *Phew*

I was pissed though, so yelled at the cow, *"Forget cheese, I'll be eating plenty of liver treats from now on!"*

Maybe cows don't like me. Whatever. I still had an incredible time in Switzerland; the mountains, wide open fields, and breathtaking scenery make it one of the most beautiful places I've ever seen.

Keep climbin',
Crusoe

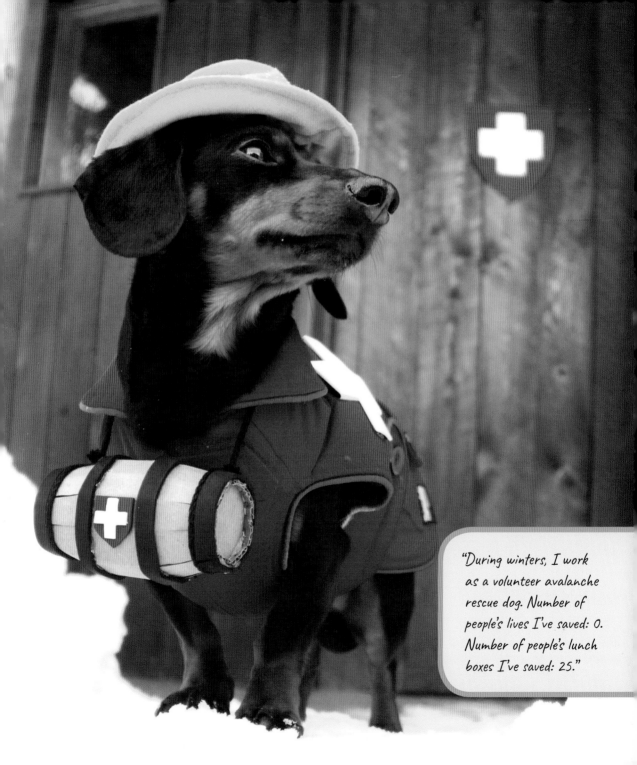

"During winters, I work as a volunteer avalanche rescue dog. Number of people's lives I've saved: 0. Number of people's lunch boxes I've saved: 25."

California, USA

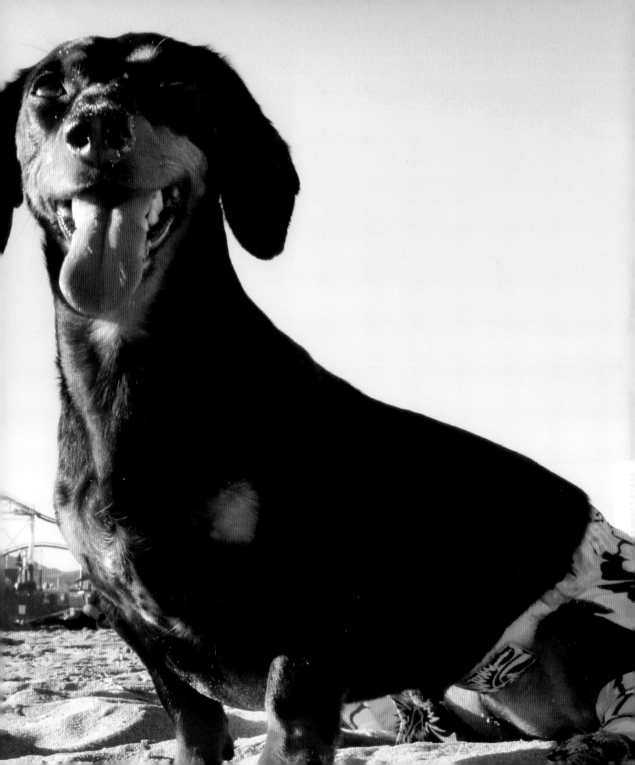

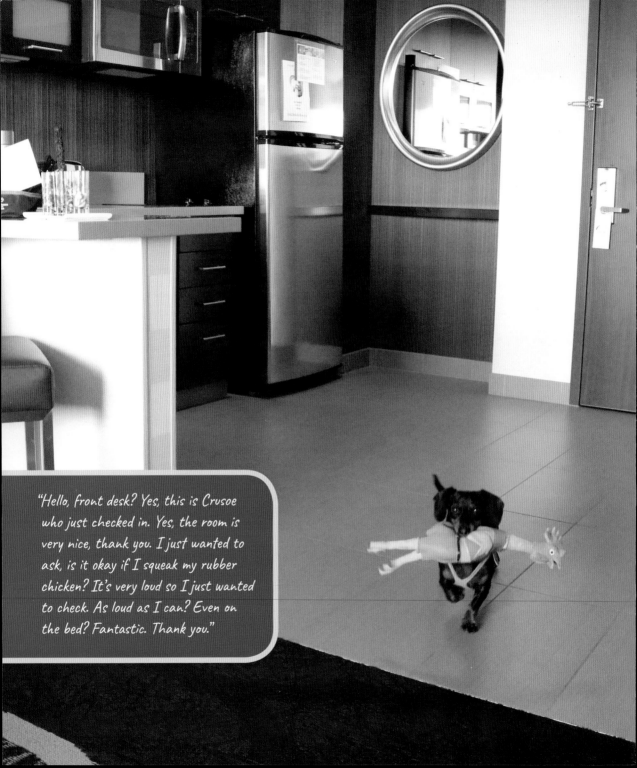

"Hello, front desk? Yes, this is Crusoe who just checked in. Yes, the room is very nice, thank you. I just wanted to ask, is it okay if I squeak my rubber chicken? It's very loud so I just wanted to check. As loud as I can? Even on the bed? Fantastic. Thank you."

Sunshine, warm weather, bikinis, popsicles, a dog-progressive attitude, and a hotspot for celebrities; California had my name all over it!

After arriving in the metropolis I'd heard so much about, Los Angeles, I was also very pleased to see Mum and Dad had finally reserved me a convertible instead of their usual donkey-cart of a rental car.

We pulled up to the hotel fittingly in style. I always love exploring my new hotel room.

The very first thing I had to do was visit my "Mecca," The Hollywood Sign. I got a good look at it, but with the sweltering heat that day we couldn't hike up close enough for a good pic.

While in the area, we headed over to the Griffith Observatory to enjoy a nice view of Los Angeles.

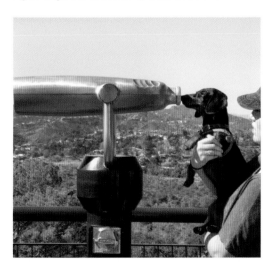

"Oh my!" I exclaimed as I looked through the telescope. "What a wonderful babe-watching invention this is! Sexy ladies, as far as the eye can see!"

"Okay, I'm putting you down now . . ." Mum said.

No no no— but it was too late, I was on the ground. I later told Dad that we should install one of those on our balcony back home.

We then found our way to the Travel Town Museum in Griffith Park; a neat little place where you can learn about the history of LA and its roots in the railroad system.

The worker crew must have noticed my shovels-for-paws, for they asked me to come help them out for a bit.

I inadvertently put them all out of a job when I later overheard the manager saying he was going to replace the whole team with dachshunds. Can't blame him, though.

Next, I headed over to the Santa Monica Pier, where all the muscular, athletic, cool kids hang out on the boardwalk. I think I did a pretty good job of fitting in.

Before we could leave LA though, I had to do one last thing:

So, I guess it's official, I *am* the celebrity I always thought I was. A huge thanks to my fan who hand-crafted this for me.

It was time to continue our journey, and before long, we were cruising north on California's famous Highway 1 toward San Francisco.

At one particularly beautiful spot, we stopped for a break and a closer look.

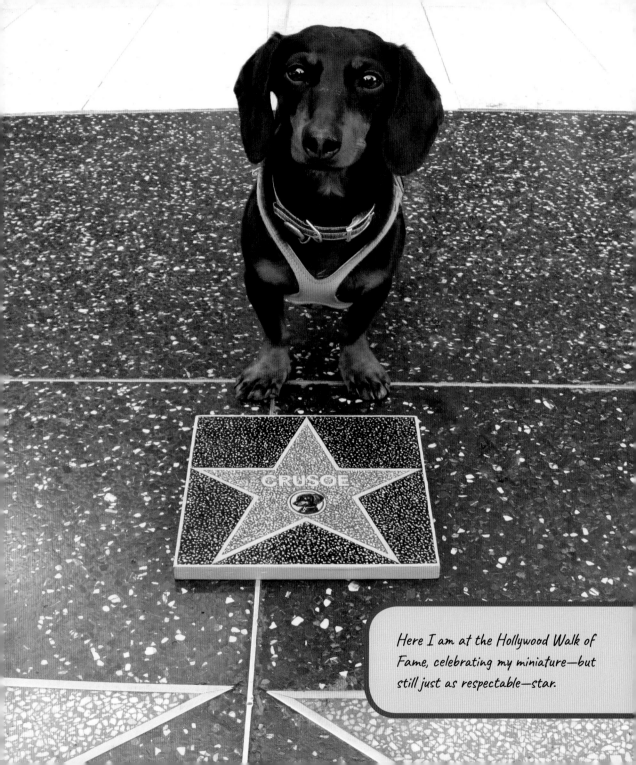

Here I am at the Hollywood Walk of Fame, celebrating my miniature—but still just as respectable—star.

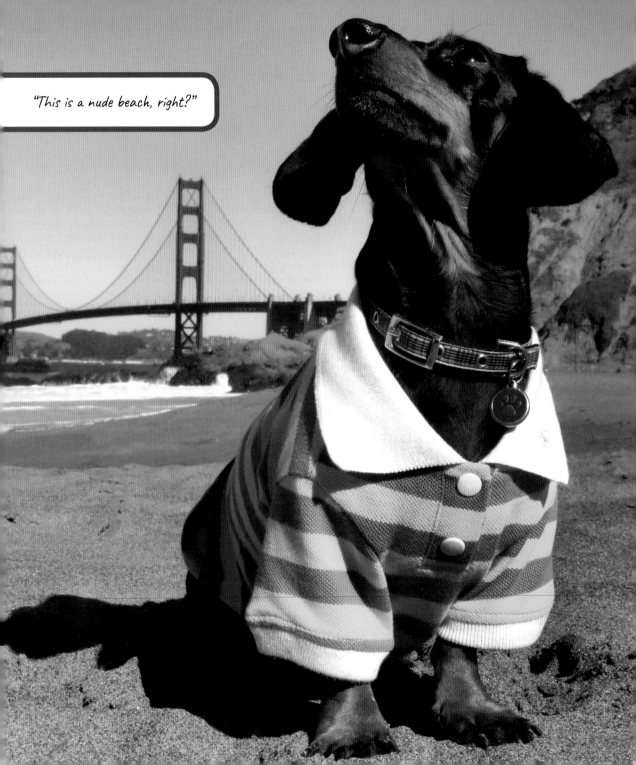

Something in that moment felt special. You know, being "on tour," cruising the California coast in a convertible, happy and healthy, and all of us together. I needed a photo to commemorate the moment for the three of us to remember. And to post to my Instagram.

Continuing our drive, we paused at Paso Robles for the afternoon to finally visit some wineries. A dog's powerful sniffer makes us automatic sommeliers.

I took a hardy sniff.

Then I took a sip, swished it around in my mouth, then gave my evaluation. "The taste is long and full-bodied like my brother Oakley in his pajamas, the bite short and mild, like he just gave you a quick nip on the butt."

The wine maker looked at me incredulously for what felt like a long moment, then shook his head and walked away to help other customers. *Phew* I bull'ed my way through that one pretty well.

I was out of commission to continue the drive, as was Dad, so Mum took over while we napped in the back together for the rest of the evening. By the time I woke up again, it was the next morning and we were in the spectacular San Francisco.

After a nice walk on the beach by the Golden Gate Bridge, where Mum even

"I'm getting undertones of oak stick . . . coupled with the smokiness of charred bacon on a summer breeze. . . . And ah yes, the subtle funk of Dad's stinky socks."

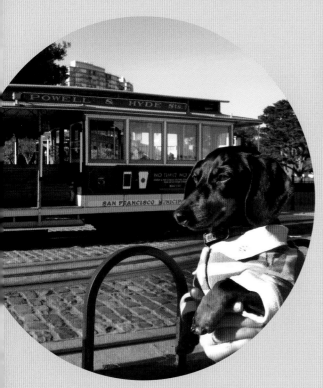

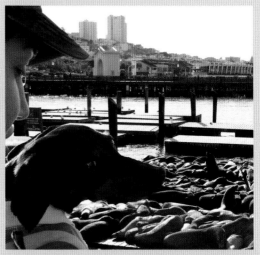

"Well, I'd still very much like to ride the history ride then."

Ding ding *Away we went!*

Well, it didn't go too fast, but I'll admit there was something magical about it. I almost felt like I was in a classic old film.

Another cool way to see the city and to especially learn about its history is to take the open-top vintage Fire Engine Tour. San Francisco has a long history "in fire," as earthquakes are common here, but it was the ensuing fires that were the problem. So, firefighters have always been a very important part of society.

When I asked if I could drive the truck, the guy said, "Whoa, wait a minute— aren't you that wiener dog that crashed his firetruck in that viral video?"

applauded me for not taking my shirt off despite it being technically a nude beach, we headed over to the iconic Hyde Street cable car turnaround.

As Mum held me for a better look over the fence I observed, "Mum, this ride does not look very exciting. . . . A children's merry-go-round moves faster than that thing."

"Crusoe, it's not an amusement ride," she replied. "It's just where the cable cars turn around so they can go back up the track. It's a piece of their history."

"No, no, that was not me," I reassured him. "That was my brother Oakley. Don't worry, his license has long since been revoked."

For the afternoon, we decided to just walk around the famous Fisherman's Wharf. "What is that strange sort of barking sound?" I asked as we approached the side of the pier. "*And phew*—that smell!"

That's when I saw them, piled up over each other on the docks, barking like madmen, and stinking up the place worse than the dumpster out back a fish restaurant.

My mind raced through the possibilities of what they could be until I settled on the most likely answer I could think of. "Are those . . . *Portuguese Water Dogs*?"

"Yes, *yes they are*," Dad replied.

Strange. Not quite as I pictured them.

We ended our visit to San Francisco having dinner on Pier 39, enjoying the sunset as all the lights came on and illuminated the place with that magical feeling once again.

 Keep cruisin',
Crusoe

"Nothing to see here. Just labradoodles being labradoodles."

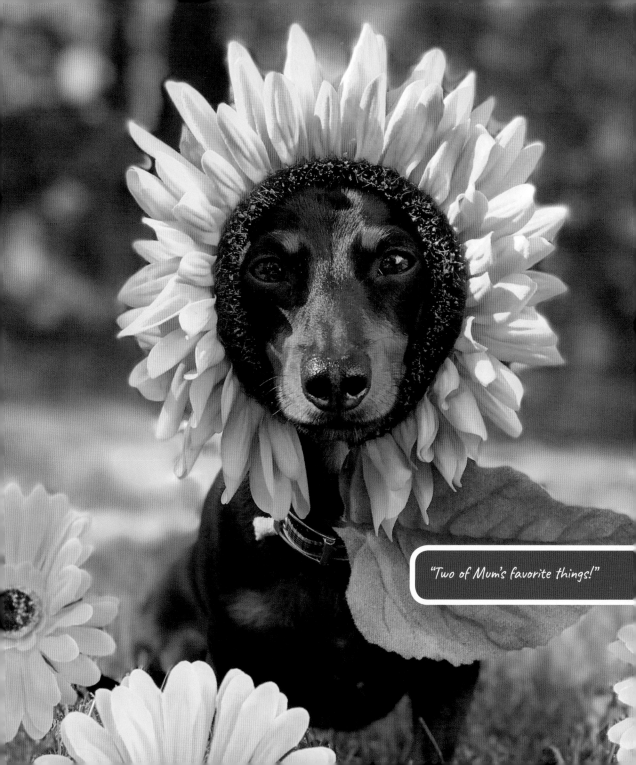

"Two of Mum's favorite things!"

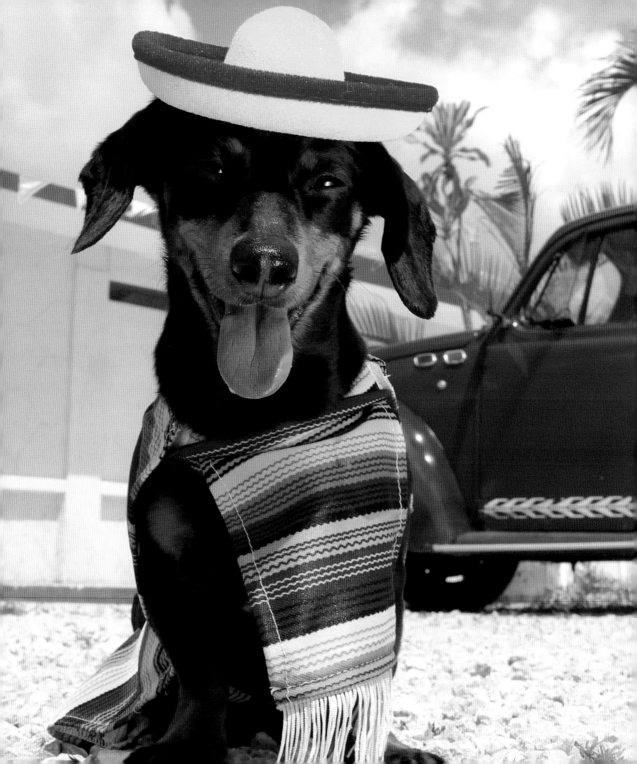

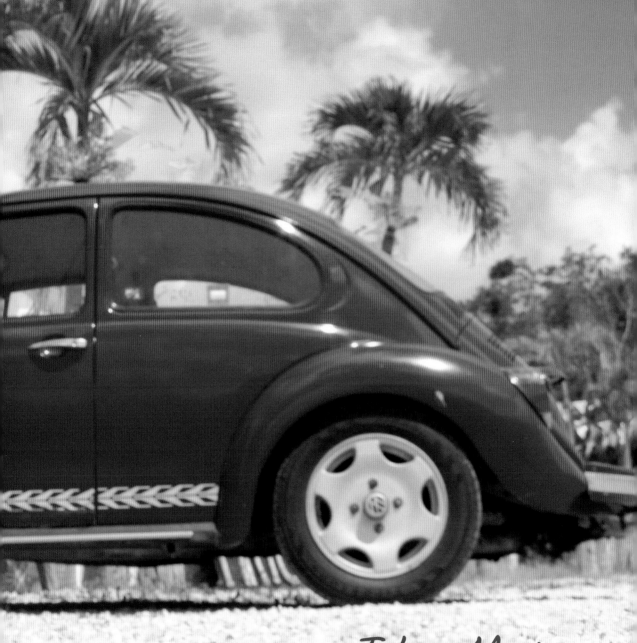

Tulum, Mexico

Aside from the expected sombrero and poncho, you might be wondering why I'm standing next to a Volkswagen Beetle. Well, interesting fact—Mexico was the last place to manufacture the classic cars before they finally went off the line, and it's essentially become a piece of their cultural heritage!

So away we went, cruising down to Tulum, a place of beautiful beaches, ancient temples, amazing food, and a very respectable movement of eco-friendly boutique hotels.

The first day we hit the beach. Mum and Dad had barely walked two steps when they looked down at me and gasped.

"Crusoe, what are you doing?" Mum exclaimed. "You weren't even alive in 1999! And this isn't Cancun, no one wants to party—"

"I'm in!" Dad interrupted.

"Great!" I told him. "Now, grab yourself a beer and tell me what it was like in 1999 so I know what I'm in for!"

As Mum tromped away pretending like she didn't know us (this happens a lot lately), we felt bad, so followed her up to a quiet spot by the bushes where they laid out a beach towel. When they had finished putting out their things, they turned around to see me powdered in sand.

With towel pleasantly half-covered in sand, I stretched out liberally to begin

"Who's ready to party like it's 1999!?"

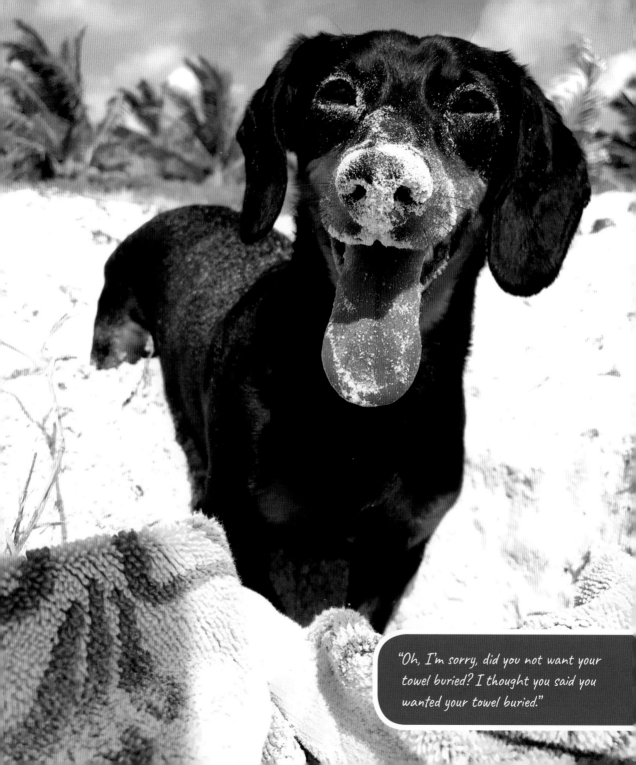

"Oh, I'm sorry, did you not want your towel buried? I thought you said you wanted your towel buried."

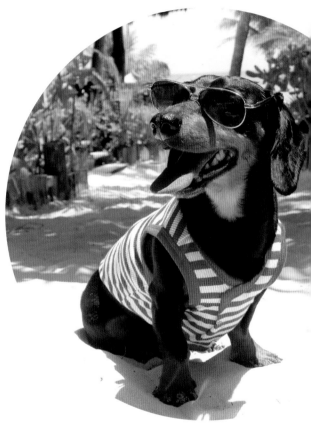

my sunbathing, a pose that Mum and Dad cutely call "frog legs," or "chicken drumsticks," and *sometimes,* Mum even says I'm so cute that she could just *"eat me up!"*

Come to think of it, it's somewhat worrying that all their terms of endearment for me seem to be food-related. . . .

Now, on a trendy beach like this, there's a fashion statement to be made. However, having such fashion-backward parents (mainly Dad) always cramps my style.

It seems Mum is always looking for a reason to cuddle though, so as

soon as she found herself a hammock she snatched me up and pulled me struggling into the depths of her web while bludgeoning me with kisses.

Which quickly made me realize I needed my own hammock.

The next day we embarked on what was likely one of the most unique experiences of my life. Not far from Playa del Carmen is a place called Rio Secreto, which offers tours through a pristine underground river-cave system.

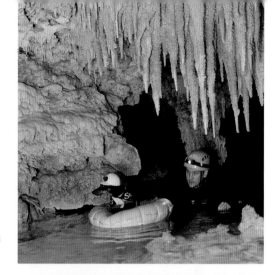

This is not something you're typically allowed to do with your dog, and in fact, because of the accessibility to the caves, no dog *has ever been inside!* Until now! I was to be the first and only dog to have ventured within.

I had no idea where I was going, yet I still stubbornly insisted I lead our party. It was a world unlike anything I'd ever seen. Mum and Dad were worried I might get scared, but I was calm and observant.

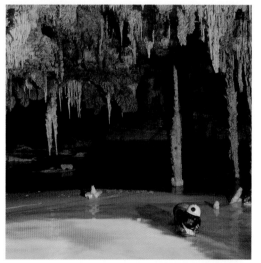

Stalagamagamites or whatever they're called, hung from the ceiling, delicately formed over millennia. Yet, all it takes is one little slip to easily destroy thousands of years of nature's work in an instant.

I continued to lead our party deeper and deeper through the chasms and tunnels, sometimes over hard ground or

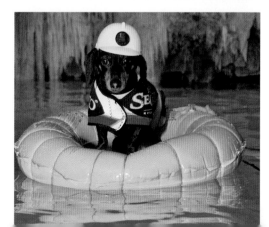

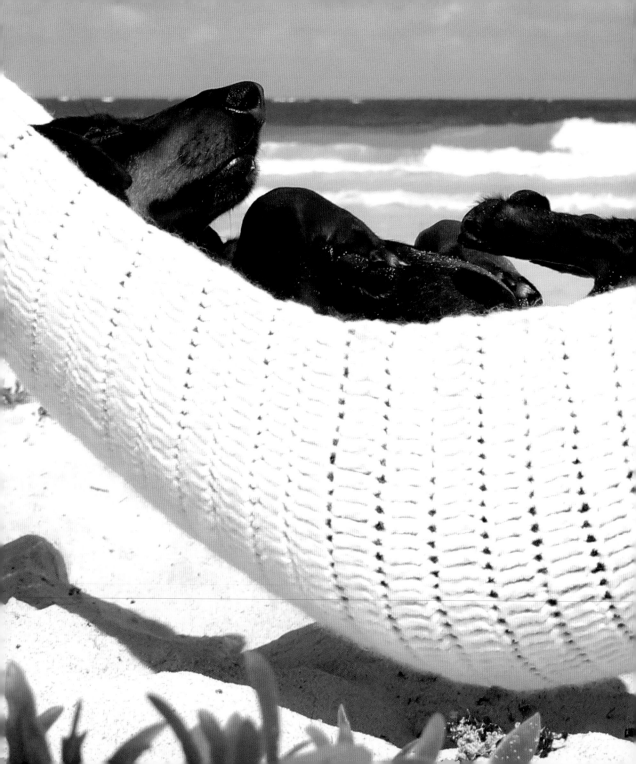

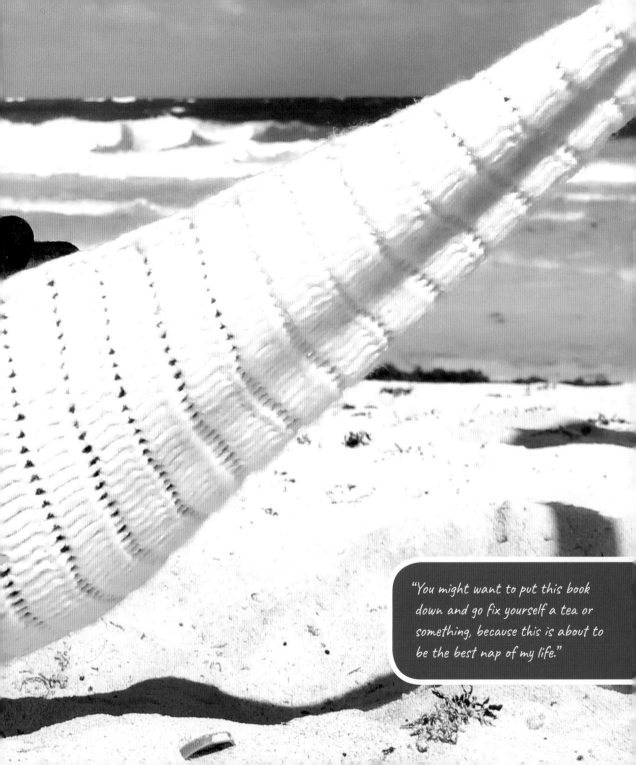

"You might want to put this book down and go fix yourself a tea or something, because this is about to be the best nap of my life."

through shallow water, and sometimes swimming. However, my worry was building, for I had no idea where I was going, and I couldn't let the team know that.

The fact that the underground cave systems in Mexico are some of the most unexplored places on earth wasn't exactly reassuring.

After several hours of wandering, I finally gave up and turned to the team and said, "Sorry guys, I'm lost."

A sense of doom fell over everyone. "How long have you been lost for?" Mum demanded.

"Since we started."

Mum threw up her hands. "Why did you insist you lead the way if you don't know where you're going?"

I didn't understand the question. A dog never truly knows where he's going. . . . He just . . . *wanders*!

Luckily, the guide pointed out that there are ropes through the caves that we could follow to the exit.

We finally emerged from the underworld (the Mayans considered these caves the underworld) to the light of day. Although relieved to make it out alive, it was an incredible adventure I'll never forget.

"Behold, the intrepid, awe-inspiring fictional character after whom I was named, Robinson Crusoe!"

Speaking of the ancient Mayans, I had to find out more about this mysterious culture, and having now discovered Mexico's caves for all dogkind, my thirst for discovery turned to that of long lost cities.

So off we went, slashing our way through the untamed jungle for hours, sweat glistening down our skin (and fur), and covered in bug bites when we finally emerged in awe at a towering Mayan temple before us.

"Crusoe!" Mum blurted through heavy breaths. "There's a road and walking access right over there. . . ."

"Yes, I know that, Mother. But do you think Indiana Jones stumbled upon ancient temples via the ticket booth and concession stand?! *I don't think so!*"

Mum rolled her eyes.

We continued onward across stonework thousands of years old, crouched through strangely small doorways, and peeked into dark crevices that could still hold undiscovered secrets to this day.

The Mayans' whole idea of building these temples was that it would bring them closer to the gods up above, so naturally, one must climb, and we headed to the only temple you can still hike up; that of Coba.

As Dad and I climbed up together, Mum clambered on behind us. Occasionally, I'd stop to ensure she hadn't fainted and tumbled down.

Dad of course carried me since I can't do stairs, and when we reached the top, he was dripping sweat and light-headed. Pathetic. I wondered how many Mayan god-points I'd receive if I pushed him off the ledge as a human sacrifice. . . . Would the gods grant me eternal life?

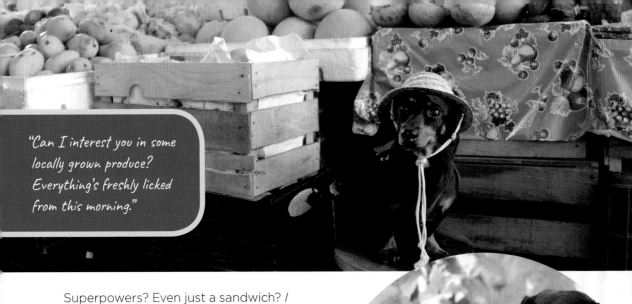

Superpowers? Even just a sandwich? *I was very hungry. . . .*

I pondered over the tough decision as Dad toed near the edge taking photos when we heard Mum's voice from below. "I'm going back down!" she called. "I'm getting dizzy."

Dad and I were both shocked. "You are so close, just come to the top!"

Yet, she couldn't do it, which was a shame. I probably could have gotten *two sandwiches* for the both of them. Now I might as well just wait for lunch.

Normally I only have tacos on Tuesdays, but since I'm in Mexico I guess I could make an exception *this one time. . . .*

"Us dogs don't like breaking our routine, especially when it comes to dinner."

Keep wanderin',
Crusoe

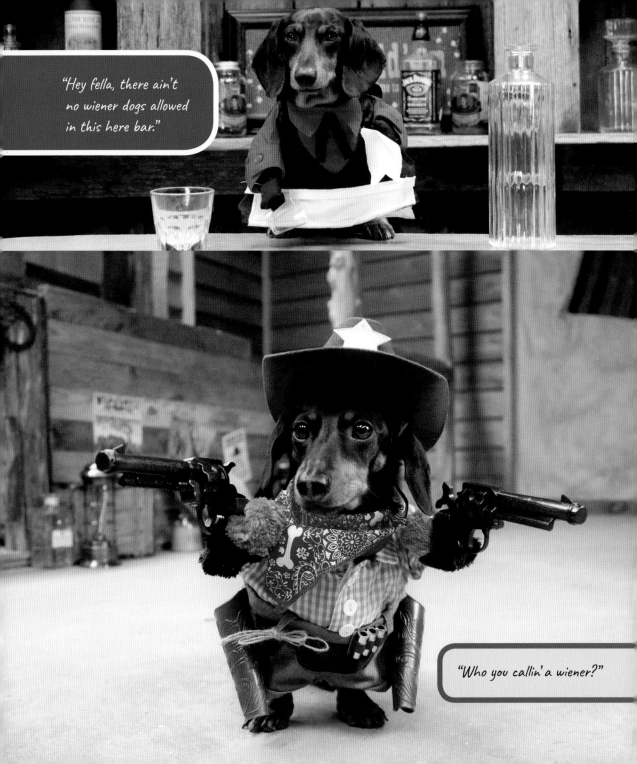

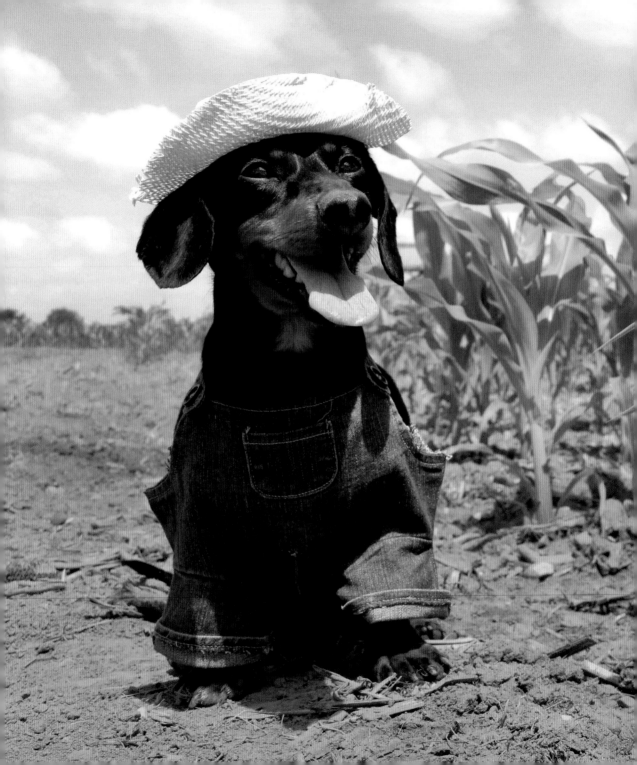

On the Farm
(Oxford County,
Ontario, Canada)

Oxford County in Ontario is a quiet little place known for its farms and cheese making. So, while there, I visited a local farmstead to lend them a paw with some of their chores in return for some of their cheese! (Since I didn't get any in Switzerland.)

The owner asked me upon arrival in the typical straight-to-the-point farmer talk, "So, what are ye' good at?"

That was a loaded question if I'd ever heard one, but I decided to keep it simple. "I can dig!" I said.

"Great, take the tractor to the edge of the field over there and plant me some corn, will ye' kindly?"

"I will kindly!" I replied.

I hopped up onto the John Deere tractor and puttered over to where she said.

I didn't waste any time getting straight to the diggin'. I didn't need any tools, for dachshunds are born with two front shovels!

With my hole dug, I took out a few kernels from my overalls pocket and tossed them into the hole.

The farmer lady came over to check on me, and, as expected, she was beyond thrilled.

Which made me think, if only Mum and Dad were this appreciative of all the holes I dig for them back home, maybe I'd be more willing to help out around the house.

"Maybe you could help me feed the goats next?" she asked.

"They do look like they want

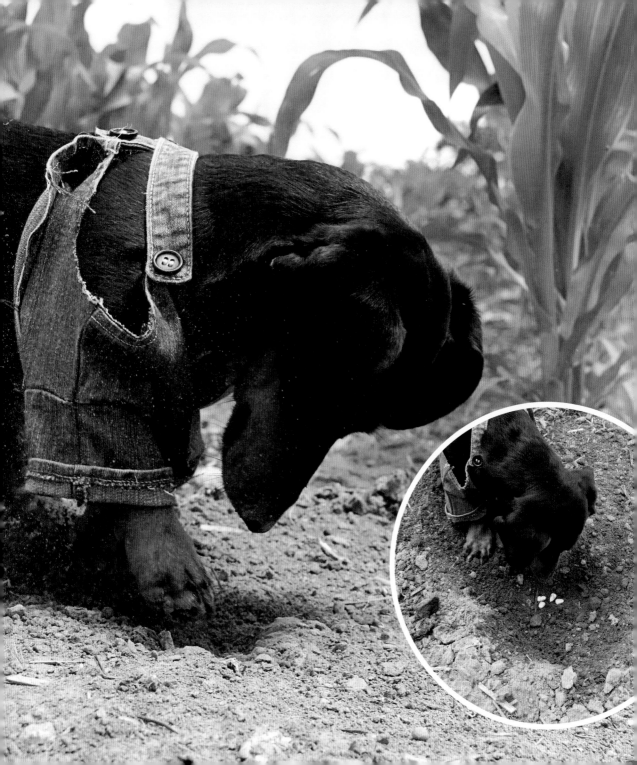

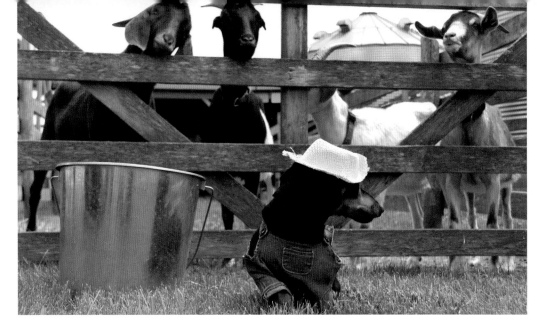

something. . . ." I agreed, uneasy having my back turned to them. I thought back to how Mum always uses food-related terms of affection for me, so I worried they might be in the mood for some dachshund.

"They probably want to eat your hat," she said. "Maybe bring them some hay instead?"

So, I rushed to go fetch some hay. I could only find this dinky little wheelbarrow so had to make *like 100* trips back and forth.

Phew This farmer stuff is hard work. I was about to throw in my hat for the day (and by that, I mean throw it to the goats), when the farmer lady asked me if I'd like to be introduced to a "chick."

"Heck, yes!"

Although, it wasn't the type of chick I was expecting.

I couldn't figure out why Mum was holding me so tight, and was about to tell her to buzz off when I noticed I was . . . *drooling*? What the heck? Next thing I knew I was licking my chops and mumbling things about Tweety Birds and

cute little chicken drumsticks! This was very odd indeed.

I realized this was my hunter instincts kicking in. Luckily, the farmer lady noticed it, too, and said, "How about some cheese for him, instead?"

No one knows cheese better than a dog, and especially a dachshund!

I could literally describe each kind of cheese here in such exquisite detail that you would be slobbering all over yourself worse than I was, but my willpower is about maxed out by now, so if you don't mind I will be devouring this in 3 . . . 2 . . .

 Keep droolin',
Crusoe

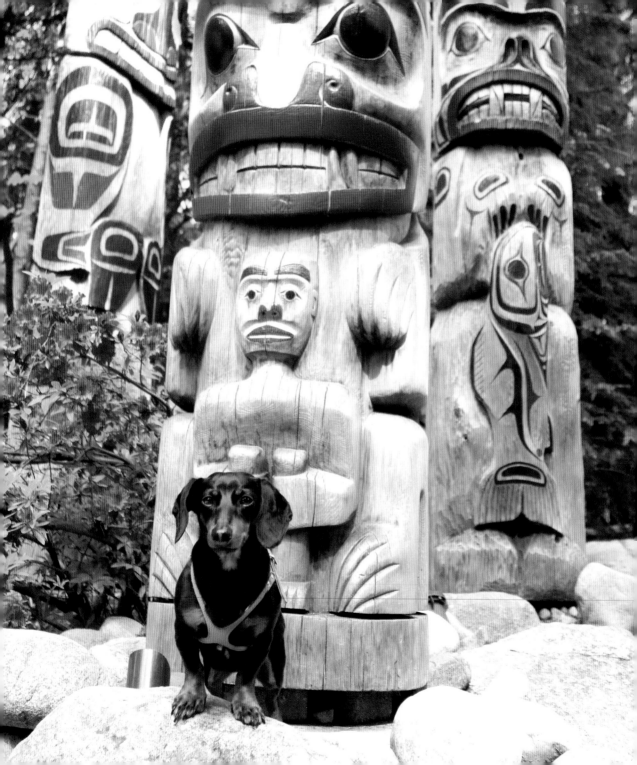

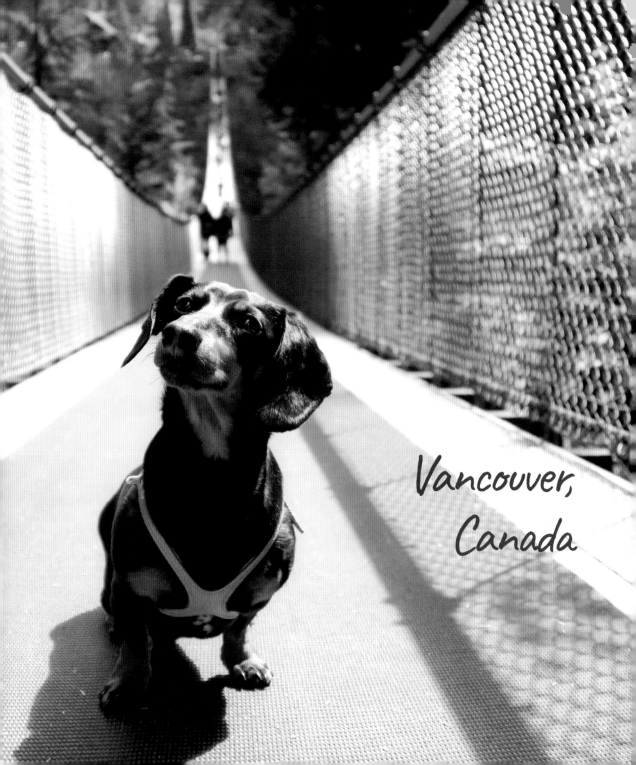

Vancouver,
Canada

ATTENTION
EXTREME
NATURE AHEAD.

My impression of Vancouver is that it's like San Francisco in that it's progressive, techy, and artsy—but greener. Vancouver is known for its beautiful gardens and lushness in the midst of the city, and still, you need only step out of downtown to be in some of the most enchanting wilderness around.

The Capilano Suspension Bridge Park features a long, springy suspension bridge across a steep valley to a towering forest on the other side. This is where I first learned that I'm not too fond of heights. I walked steadily across, feet apart like a cowboy, slow like a turtle, and never stopping to look down.

A huge sense of relief overcame me as I reached the other side. That is, until it dawned on me: "Shoot, *now how do we get back*?!"

Yet, seeing this sign on the other side, I knew I was in the right place.

Now if you'll excuse me, I have some nature to pee on.

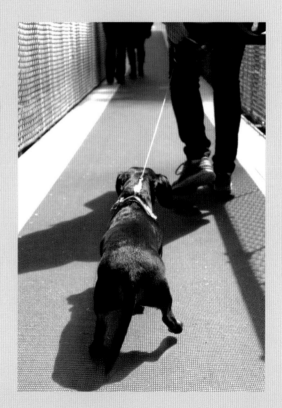

Keep movin',
Crusoe

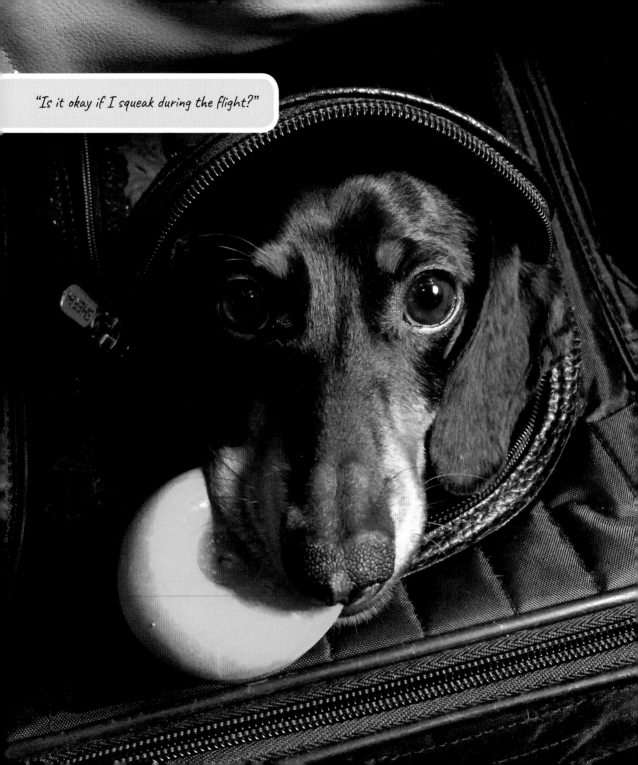

"Is it okay if I squeak during the flight?"

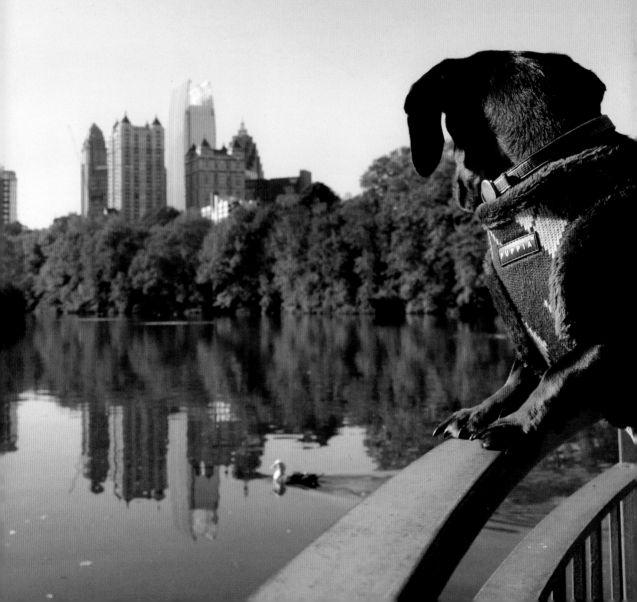

Atlanta, Georgia, USA

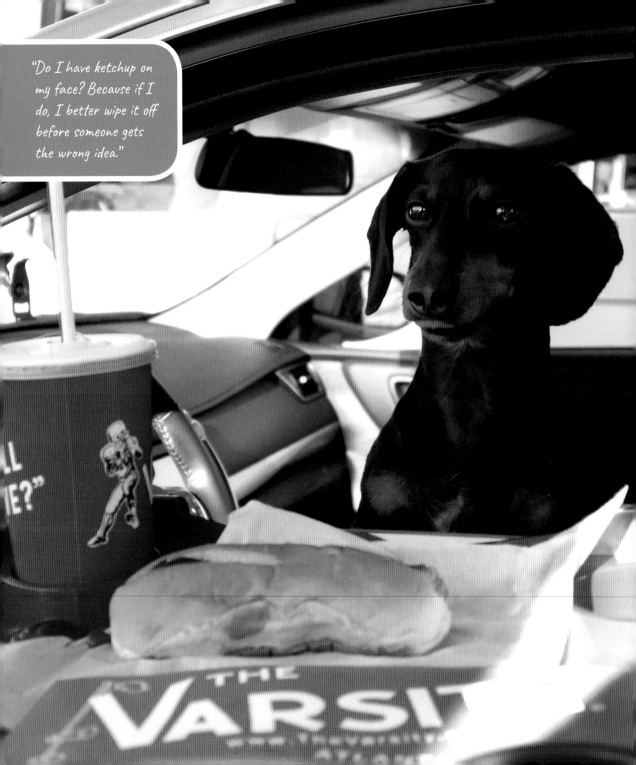

ARRIVED

HARTSFIELD–JACKSON ATLANTA INTERNATIONAL AIRPORT

ATLANTA
★ USA ★

While in Atlanta, we followed the recommendation of visiting the famous Krog Street Tunnel in the eclectic neighborhood of Cabbagetown (*Who the heck came up with that name?*). This graffiti-filled underpass is truly a work of art.

I was also told that, somewhere in and around the tunnel, I should try to find the "tiny door"; a new trend going around that's got people trying to find all these tiny doors hidden around the city.

With my expert sniffer, it didn't take me long to find it. "Hey Mum, I think someone's cooking cabbage in here. . . ."

I didn't bother knocking to avoid any sort of impromptu dinner invitation.

It also seemed I had no choice in the matter of visiting the iconic The Varsity, the world's largest drive-in restaurant since 1928, and known for their impatient greeting of "*What'll ya have? What'll ya have?*"

Keep knockin',
Crusoe

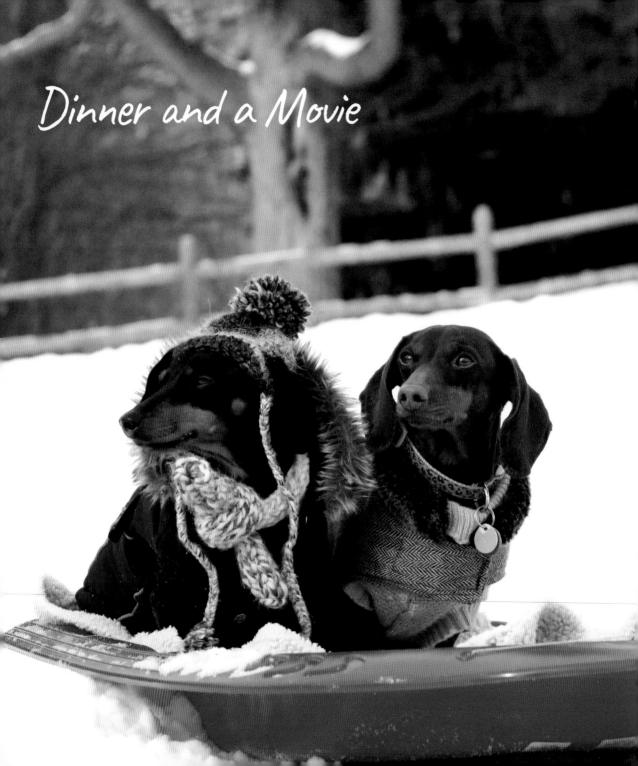

Dinner and a Movie

One thing they don't tell you about being a celebrity on the road all the time is that it's very hard to find time for dating.

So, I gave Paisley a call to go out for dinner and a movie; a cute girl I met once before while at one of my epic bikini pool parties.

"Knock her socks off!" Mum said as I left for my date.

So with a rose in paw, I patiently awaited my date on the edge of my chair, a keen eye on the restaurant entrance.

The door swung open and in walked Paisley. She trotted over to the table and hopped up onto the chair across from me.

"Oh, thanks," she said, barely acknowledging my gift, her nose held high, casually sniffing the place out as if the stinky bum of the waiter was more appealing than my rose-soaked skin and man-musk cologne.

I quickly texted Mum under the table: *MUM—Paisley barely seems interested. Why is she not swooning over me? Why have her socks not been knocked off?*

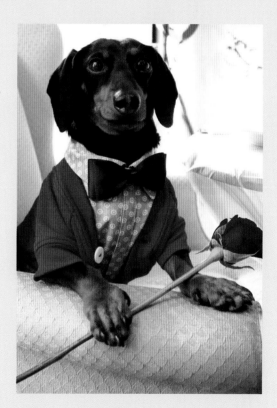

Why is she even wearing socks to begin with?!

Mum texted back: *Don't worry, just be a charming gentleman and she'll come around.*

I popped back atop the table. "Ahem, excuse me, I was just—uh, admiring your lovely socks. But you do look stunning in your red dress and pearls I might add."

"Oh, thank you." Finally, she blushed and flashed a smile.

I felt the time was right to order

drinks, so I had the waiter bring us a bottle of their finest.

With drinks poured, I asked Paisley to tell me a bit more about herself.

"Well, I'm 4 years old and a quiet country girl. I like walks in the woods, trying on new outfits, and posing for my Instagram."

"Oh lovely! That sounds a lot like me. So, are you an aspiring star yourself, because I could make you an overnight celebrity if you like?"

"No, not really. I just enjoy posing for pics and doing my thing. And well, if that's what makes me famous, then so be it!" she said with a smile.

"Well that's pretty much how I got famous. Not to mention half the celebrities out there today (*cough* Kim Kardashian *cough*). Speaking of famous, we need more champagne."

Our chit-chat flowed seamlessly through dessert and to the movie theater.

Sharing a seat, popcorn bag between us, I asked what she was looking for in a man. She said someone who's caring, gentle, funny, strong, fashionable, romantic, and a protector.

"Well, I like to think I'm all those things," I replied. *"Not to mention a*

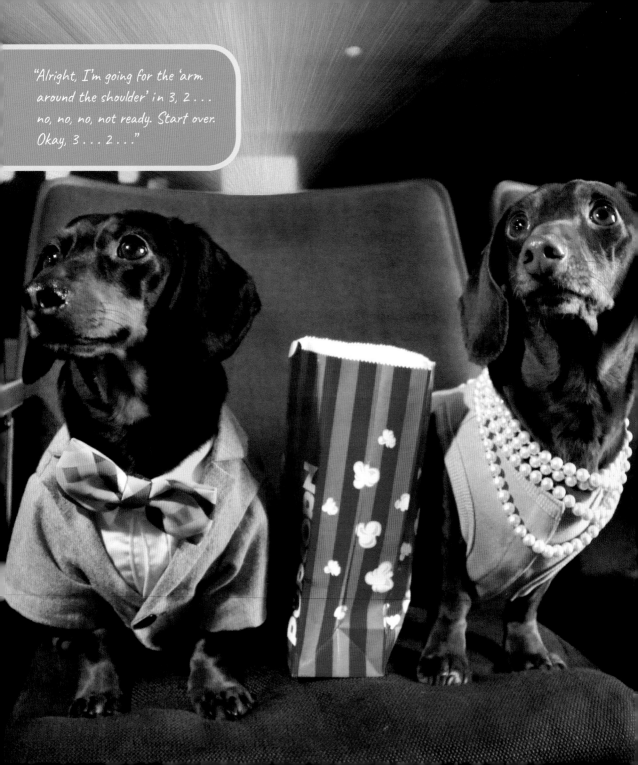

"Alright, I'm going for the 'arm around the shoulder' in 3, 2 . . . no, no, no, not ready. Start over. Okay, 3 . . . 2 . . ."

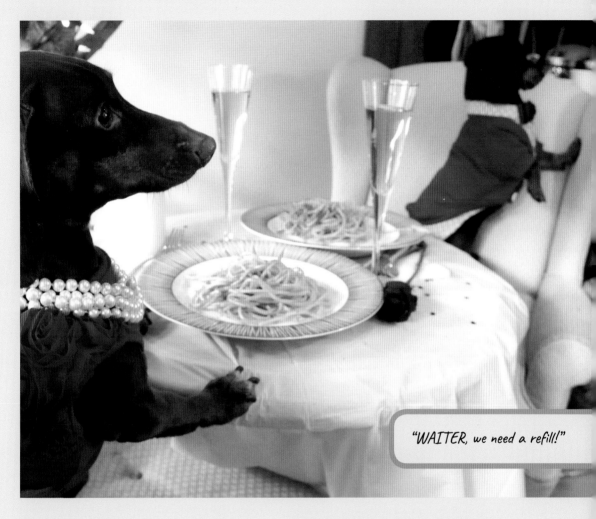

"*WAITER, we need a refill!*"

doctor, psychiatrist, hunter, accountant, captain—"

"Did I mention modest, though?" she interrupted. I made a mental note to look up "modest" in the dictionary later.

We had a lovely time at the movies, although I was a bit distraught when I looked over to see Paisley had eaten all the popcorn when I barely had two bites!

Afterward, I invited her back to my place to hang out a bit. Now, Dad has always said he's the best womanizer he

knows, so when he suggested I give her a box of chocolates, I did just that.

"But dogs can't have chocolates!" she exclaimed when I presented the box.

I opened the lid. "No, look, I gave all the chocolates to Dad and replaced them with cookies for you!"

"You . . . *You did all that for me?*" she answered.

I was about to reply when, *BAM!* Just like that, she planted a wet one on me right upside the sniffer.

"Thanks for the nice evening," she whispered. "And for being so charming." That made me sturdy up a little. "Hey," she continued under her breath, barely audible. "Can you make me an overnight celebrity?"

My eyes lit up.

"No, NOT the way Kim Kardashian did!" And we both laughed.

Keep datin',
Crusoe

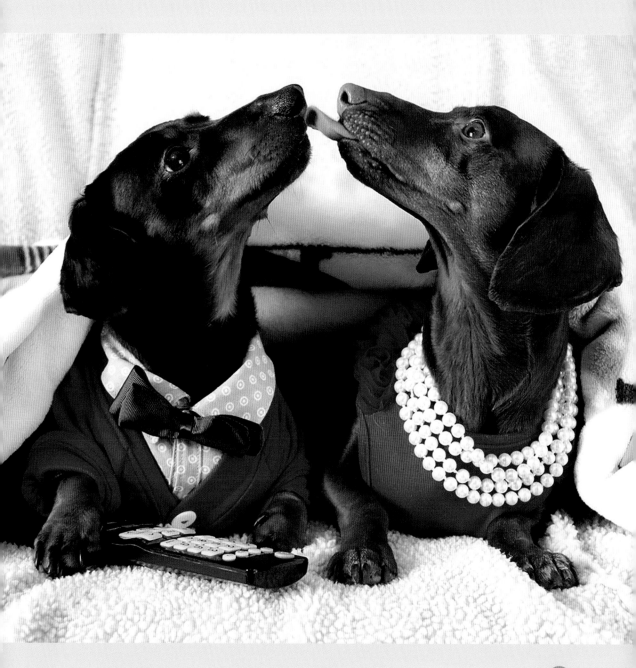

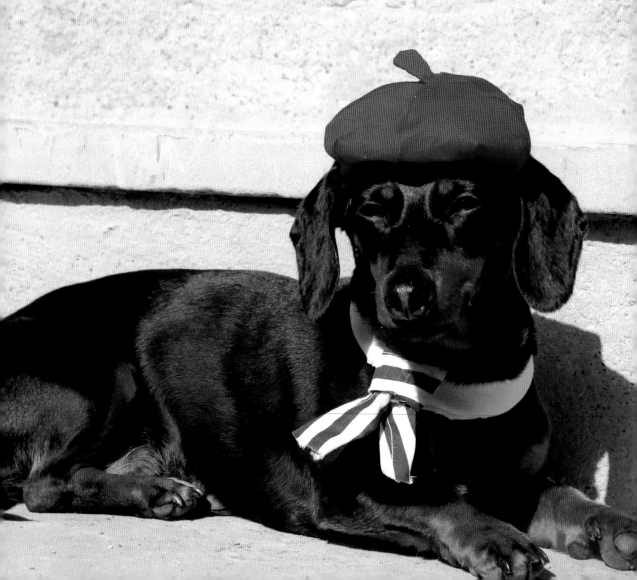

Paris, France

As you can imagine, I was well-suited for the romantic capital of the world. I even speak the language of love, *le français!*

We landed in Paris straight from Toronto, so were still quite tired, and thus decided a laid-back boat tour along the River Seine would be a nice little introduction to our visit.

This bridge had some impressive gold statues atop its columns, which reminded me—I really need to get on commissioning a sculptor to create my own gold statue one of these days.

Then, just like that, I was staring up at the iconic Eiffel Tower.

At the top of that thing would probably be a good place for my statue, I thought.

Yet, I didn't realize how jet-lagged I was until the rocking of the boat put me right to sleep, snoozing away on Mum's lap with dreams of gold statues atop tall towers.

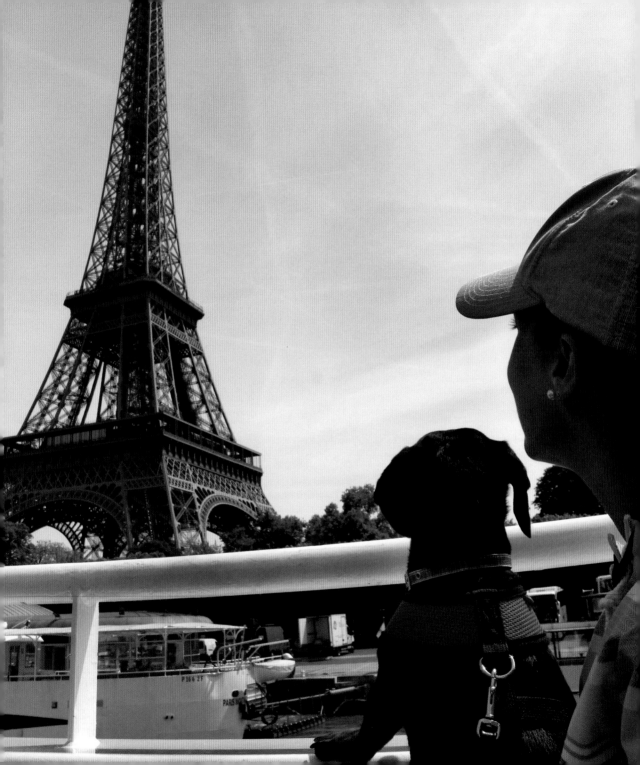

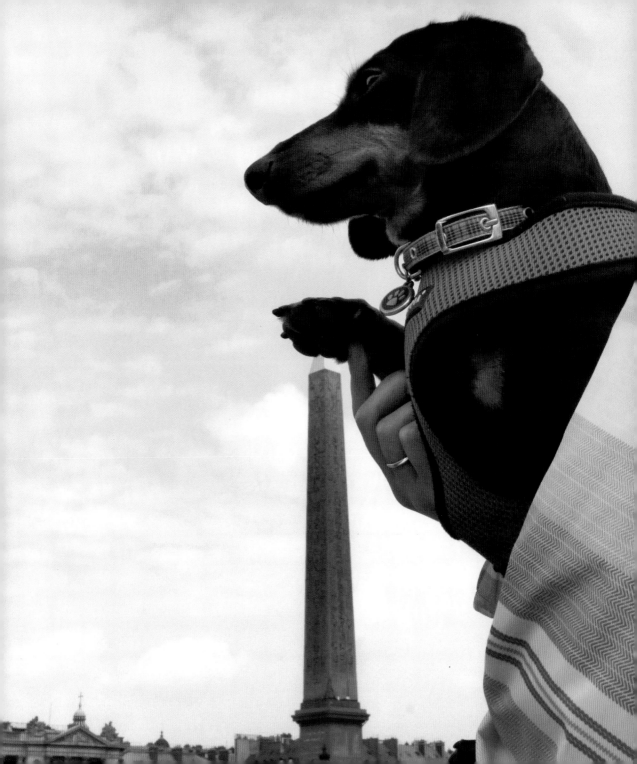

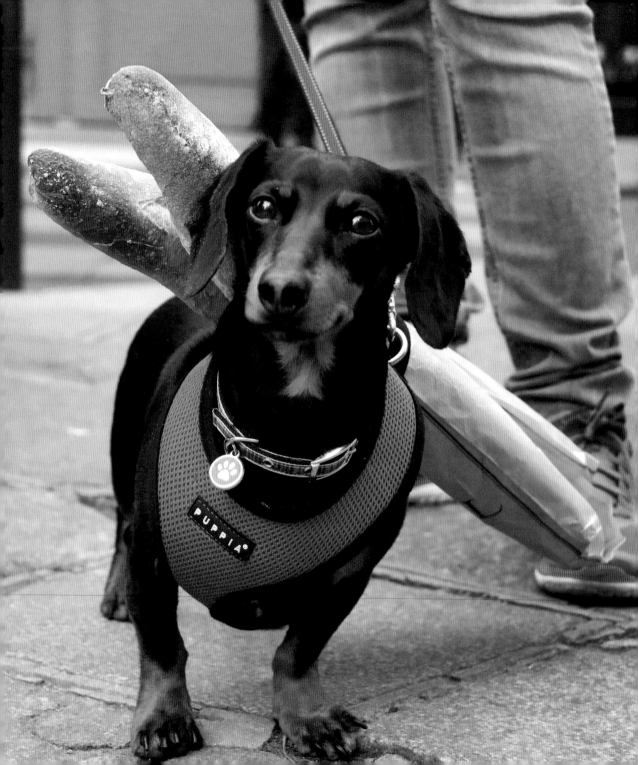

Back at the hotel, the tables had turned when Mum found herself conked out on the bed and me with a renewed energy to play! I figure if she ever has kids one day, I'm giving her plenty of practice!

Paris (and much of Europe) is incredibly dog-friendly, but the museums generally don't allow dogs. However, there's no rules about chasing pigeons in the courtyard!

I like to think I'm a classy traveler, but even I'm not immune to throwing some of the most cliché tourist poses if it means I'll get a good reaction from my Instagram followers. ☺

The next day we decided it would be nice to do as the Parisians do, which is to pick up a bottle of wine and some cheese and enjoy a picnic along the River Seine for the afternoon.

Of course, we needed a couple fresh baguettes to go with it. Luckily my harness made for a perfect carrier.

The picnic was romantic and delectable. However, it seemed Karma caught up to me when those dang pigeons returned for a piece of my lunch.

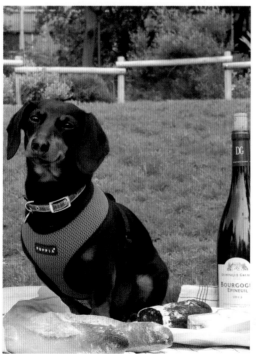

Keep Frenchin',
Crusoe

Crusoe, the Worldly Wiener Dog

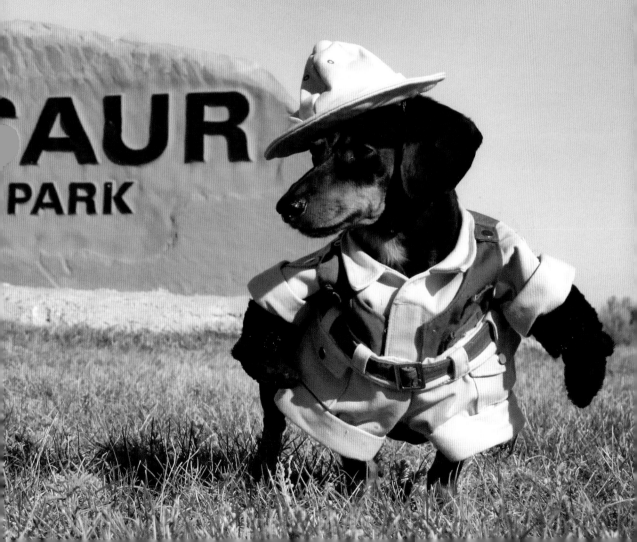

Dinosaur Provincial Park,
Alberta, Canada

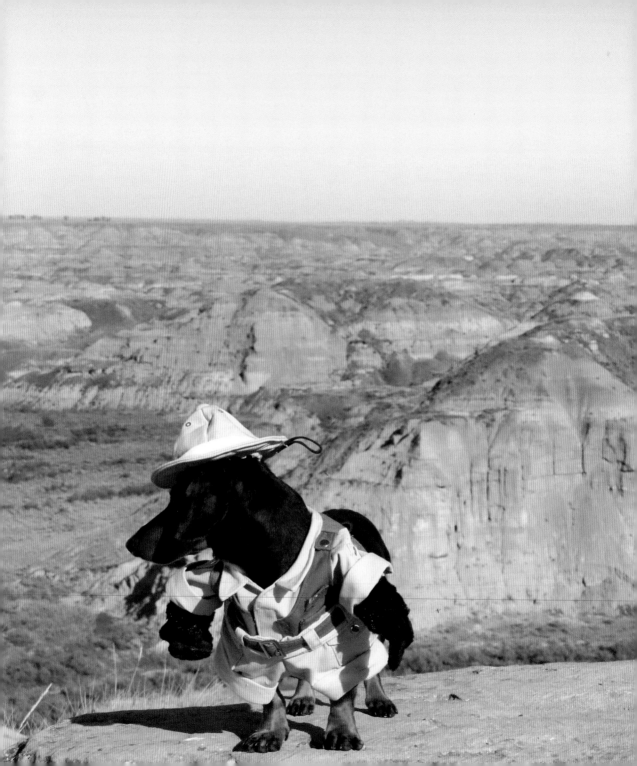

Queue Jurassic Park music . . .

As an aspiring paleontologist, I was absolutely thrilled at the prospect of exploring Alberta's Dinosaur Provincial Park in hopes of discovering some ancient fossils, or perhaps even a new species of dinosaur!

This place is like something from another time. Right in the middle of the grassy plains, where cattle graze and farmers busy themselves with chores, the ground suddenly gives way to this desolate chasm of badlands.

Many people DO find fossils here. It's not uncommon to find little fragments of bone or even a tooth after a big rain since the clay-rich rock is so soft and easily washes away.

We first stopped by the welcome building to meet with one of the park's rangers and paleontologists. She told us a bit about the park and went over a few rules. As a dachshund, I don't really pride myself on my ability or willingness to follow rules, so I wasn't really listening— that is, until I heard her say, *"No digging allowed in the park."*

"What?" I barked.

"Yes," she said with a serious crook in her brow. "You can pick up anything on the ground surface as long as it has become dislodged, but you can't dig as that could disrupt potentially important finds."

I wanted desperately to reply, but instead I bit my tongue. We all knew that a dachshund's urge to dig is so accumulative and explosive; telling me not to dig was like telling this lady not to poop for a week.

She continued blabbing about something else, but the thought had me so flustered that I couldn't help but blurt out, "YOU try not pooping for a week and see how YOU feel!"

They all looked down at me in bewilderment.

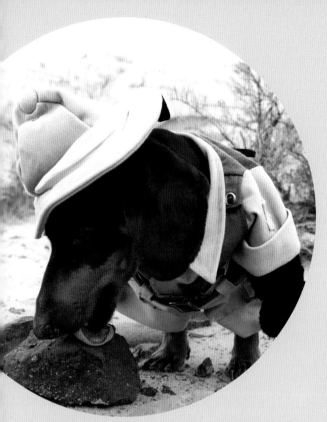

ordinary rock can be tricky, and there's no way I can impart years' worth of tutelage, but there is one trick I can share with you.

It's called the lick test, which us dogs are already well-accustomed to. All you have to do is lick the rock, then touch your finger to it. If your finger sort of sticks to it, then it's a fossil. If not, people might think you're weird for licking rocks.

I puttered around the ground, licking everything in my path.

That's when something caught my ~~eye~~ tongue. "What is this?!" I barked. "Mum, Dad, grab the tools and come over here!" Jutting out from the earth was a bone. Of what, I couldn't be sure yet.

We got to work, Dad on security patrol to keep watch for park rangers, and Mum using the brush to gently swipe away the sand. But the progress was painstaking.

"But Crusoe, that's not best pract—"

I had already jumped in, putting my two front shovels to work at full throttle. Was I disregarding the archaeological code of ethics? Breaking the park rules? Yes, but you try not pooping for a week and see how far you get.

The soft sandstone broke to silt under the crushing power of my paws, chips

Oops. Haha. "And save me some Skittles when you reach the rainbow!" I yelled. I figured I might as well go for crazy.

"Is he okay?" the lady asked.

"Yes . . ." Dad said hesitantly. "But we best be going. Only so much daylight left!"

So, with a sigh of relief, we exited the building, and headed out into the badlands.

Now, identifying a fossil from an

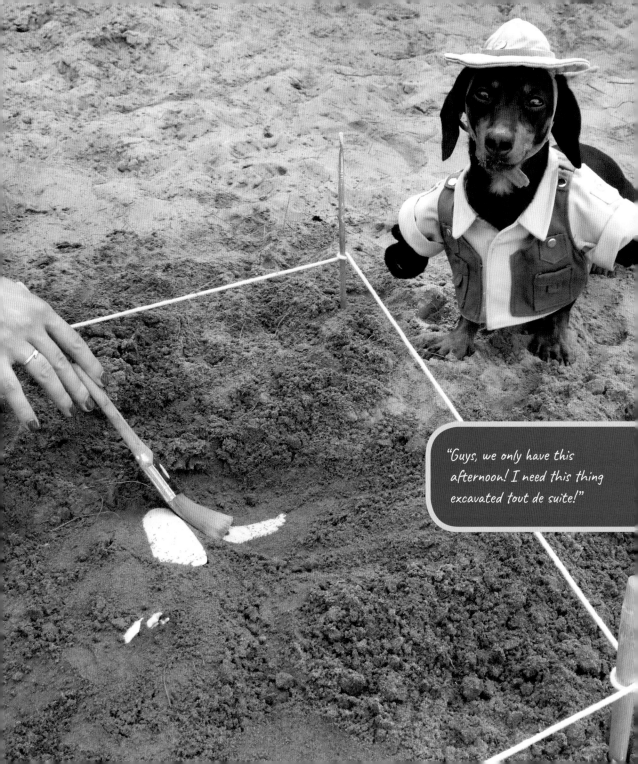

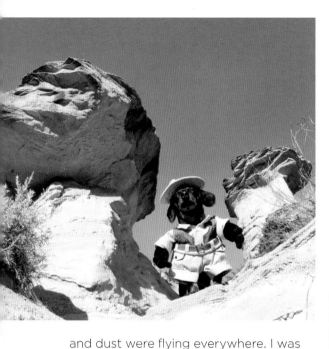

"Dad, take my photo here by these hoodoos. I need an iconic image for the cover of National Geographic Society once my discoveries are published."

and dust were flying everywhere. I was getting dirty and loving it. Finally, the skeleton began to reveal itself.

"My golly," I said, brushing a bead of sweat from my whisker. "I do believe this may be a new species. . . ."

I proudly displayed my new *Wienersaurus* discovery at their head showroom. Not many people—let alone dogs, can say they've discovered and named a new species of dinosaur. You'll surely see my name in many textbooks and publications, once they get around to updating them.

In the meantime, I have a long legal battle ahead of me for discovering this while breaking park rules. Luckily, I'm a lawyer, too.

Keep . . . *diggin'?*
Crusoe

Disclaimer by Mum:
The digging photo was taken outside the park.

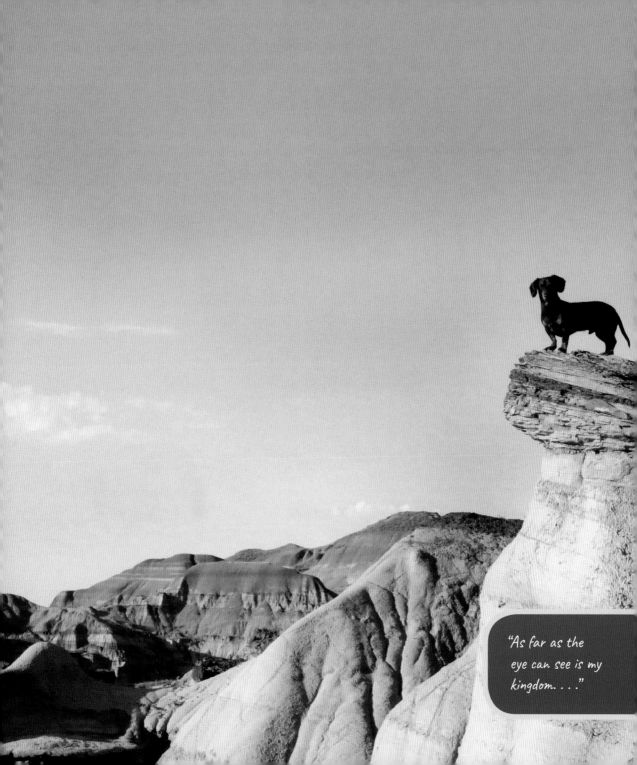

"As far as the eye can see is my kingdom. . . ."

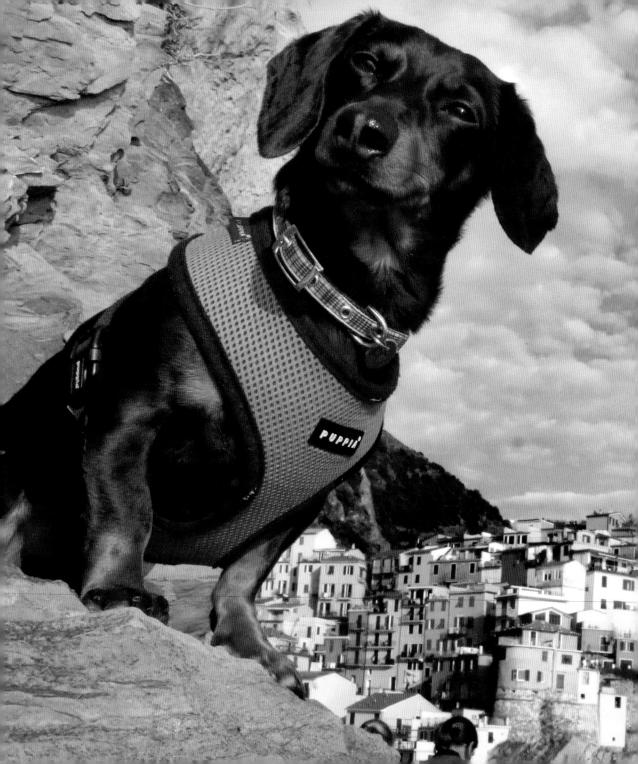

Cinque Terre, Italy

One of the most stunning places I've visited is the World Heritage Site of Cinque Terre, meaning, five lands, since there are five distinct little villages in this coastal region.

We were staying in the one known as Manarola, in what was likely the best home rental there is. So, without a moment to lose, I took off, leading the way through the throngs of people and down across the old pier.

After a long day of lugging around baggage—or in my case, *being bagged and lugged around*—the view was definitely worth it.

Cinque Terre is best known for its picturesque seaside villages, but also for the beautiful hiking trails that connect them.

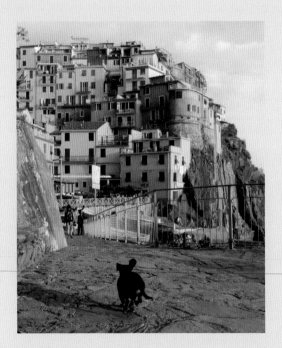

The paths carve their way up the valley slopes and along the coast, traversing their way through vineyards and olive trees and lemon groves, sometimes easy going, and sometimes very steep with seemingly endless flights of large stone steps, along which Dad would then carry me in his sling bag.

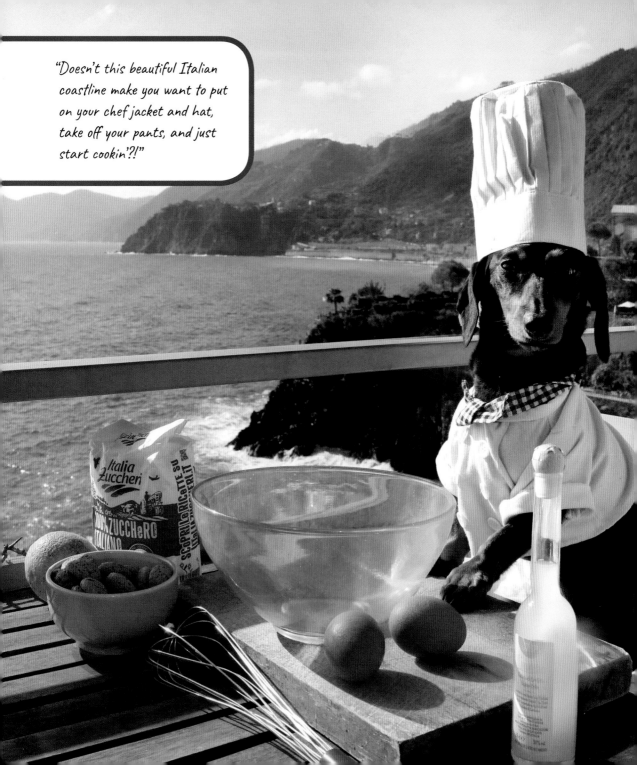

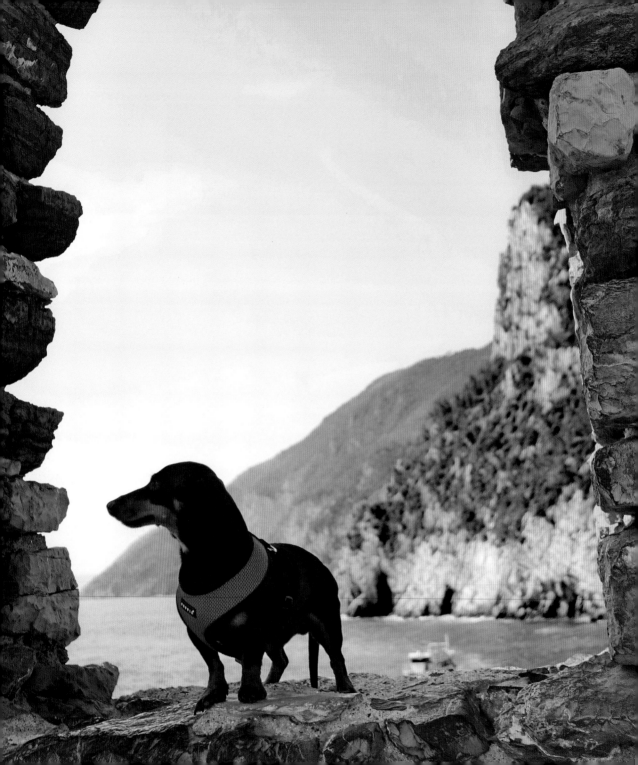

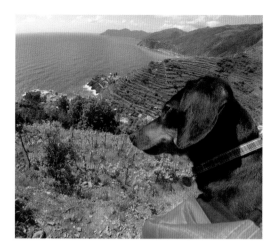

owner replied that he preferred dogs over people. So, for once I got to sit at the table while Mum and Dad huddled uncomfortably underneath.

The best way to explore Cinque Terre, though, is by boat.

We chose to go with a friendly, *very enthusiastic* local man named Stefano and his boat, the *Matilde*. Now I know what you're thinking—how could I possibly *NOT* be the captain? Well, it was hard for me, but since it was Stefano's boat, I agreed to be his second sailor in command.

As much as I like to break trail, sometimes it's nice to hitch a ride and see Mum and Dad pant and sweat like a couple workhorses.

The views from the top were something to take your breath away.

We would always end up somewhere different and interesting, like a quiet village, an old ruin, or the beach. I was smart to pack my Speedo to fit in perfectly with the European crowd.

I felt like one of those pre-wrapped sausages with that thing on . . .

Some people had warned us Italy might not be as dog-friendly as France, but I'd say it's even more so, perhaps! When Mum called to make a reservation at the fanciest restaurant in the area, she asked if I could tag along. The

Besides, I'm on vacation after all!

We arrived at the beautifully colorful town of Porto Venere, where we (I) tied off the boat to go explore.

Onshore, we went to visit the old castle built atop the bluff. I know it's hard to look past the handsome object in the window, but if you can, there's a pretty nice view out and beyond.

However, my favorite activity of all was inland—at a quarry. Doesn't sound too exciting, right? *Wrong!*

Here I stand upon a piece of the *finest* marble in the world, from one of the *largest* marble quarries—that of *Carrara*!

Everywhere you look are cliffs of glistening white marble from which massive blocks have been carved away, creating the impression that the whole mountainside was constructed of giant Legos.

I didn't just come here for a tour though. Originally, I thought my statue should be made of something flashy, like gold, but it needs to be sculpted from masterpiece-worthy material; something of unparalleled quality and a rich history.

So, what better choice than the very same marble that Michelangelo used to carve the statue *David*?

"That one over there!" I called.

I asked the tour guide how much this one would be. "80,000 euros you say? Not a problem. Mum, Dad, put it on my credit card, would you? Then FedEx this baby home!"

Mum and Dad looked a little shocked—but then again, that's the impression I'm going for. Now that that's taken care of I just need to find this Mr. Angelo fellow. . . .

Keep searchin',
Crusoe

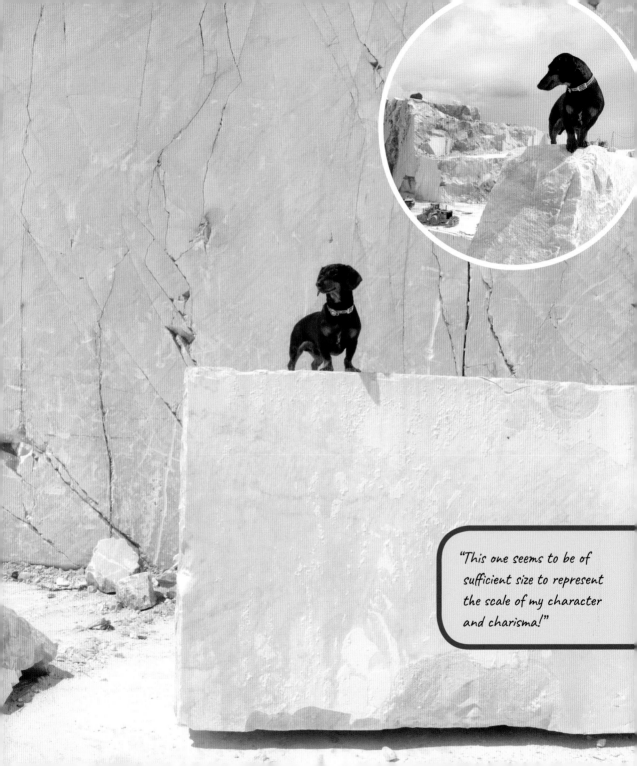

"This one seems to be of sufficient size to represent the scale of my character and charisma!"

St. Lucia, West Indies

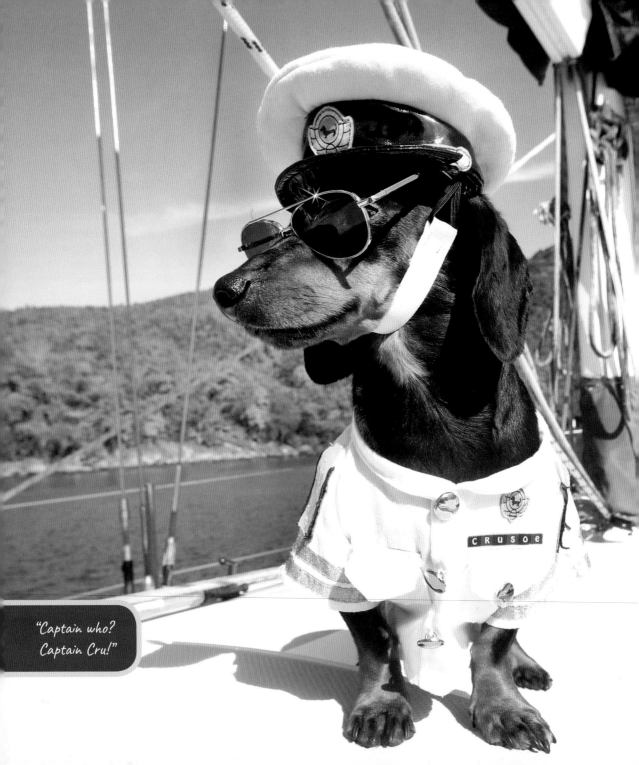

"Captain who?
Captain Cru!"

St. Lucia is one place Mum has wanted to take me to for a long time, and I'll tell you why.

She spent the first seven years of her life growing up on this little Caribbean island while her parents got a new villa rental business up and running called Oasis Marigot. To this day, she still works for the family business.

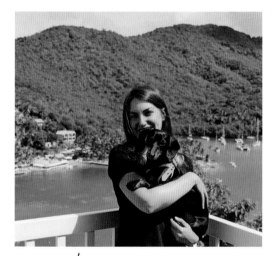

"Wow, Mum! This is beautiful!"

Understandably, she was so happy when she finally held me in her arms on the balcony of the tropical home she grew up in.

St. Lucia has so much to offer, from beaches to incredible mountainous topography. Not to mention delicious food, friendly people, and plenty to do.

Speaking of things to do, I think I'll go do nothing on the beach for a while.

I think this is why so many of my fans say they live vicariously through me. . . .

Mum thought it would be cute to commemorate the moment in typical beach-vacation style with a photo of me next to the place and year written in the sand.

Well, it was a nice *idea*, anyway, but she should have known better.

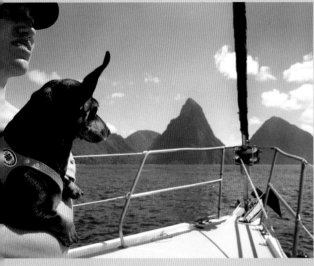

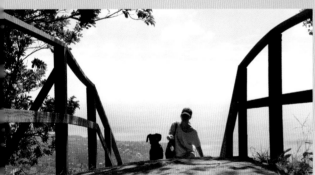

After an *even ruffer* next morning, it was time to get out and explore!

One of Mum and Dad's favorite activities is the day sail tour that takes you out to cruise down the west coast of St. Lucia to the site of the renowned Piton mountains.

It's a pretty cool feeling when those majestic peaks seemingly rise from the horizon.

From here, we took a land taxi to go explore some more places, including a little hike to get a better view of those majestic peaks.

I led the way as fearless explorer, my loaded pack mules struggling behind me with my provisions for the expedition (cookies, water, camera gear, outfits, etc.).

It was worth it though. This perspective is a little higher than my usual fourteen inches off the ground. . . .

While still in the area, Mum insisted we go visit her favorite botanical gardens, not something I was particularly enthralled about, but was of course willing to do so to make her happy. Incredible. Truly miraculous. Astonishing. A masterpiece of nature. The most beautiful thing I've ever see—

"Okay, Crusoe," Mum interrupted. "I get it, they're just flowers. But they are pretty, aren't they?"

However, I was sincerely impressed with the gorgeous Diamond Falls located within the garden.

I have a knack for mining and finding precious stones, so asked Mum if I could dig around the falls to find some of these diamonds.

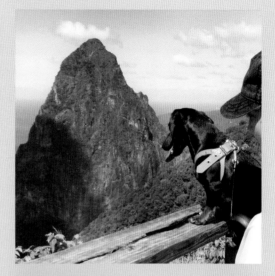

However, she informed me it was only called Diamond Falls because of its bedazzling colors created by the minerals in the water. "It means so much to have you here," she said, with a kiss on my forehead. "That is more precious to me than diamonds."

"Why are you always asking Dad for a diamond ring, then?" I asked smartly. I also made a mental note to do some exploratory digging anyway.

Now, history is usually pretty boring unless I'm in it, which is why I was rather skeptical when we went to visit one of the island's many historic sites called Pigeon Island National Park. It is here that an old fort sits atop a little island at the very north of St. Lucia, keeping watch over the open seas for enemy vessels and pirates.

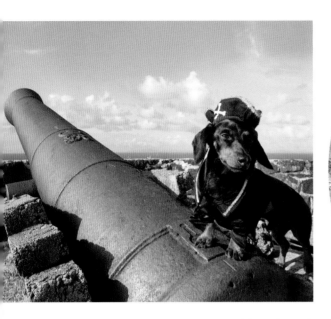

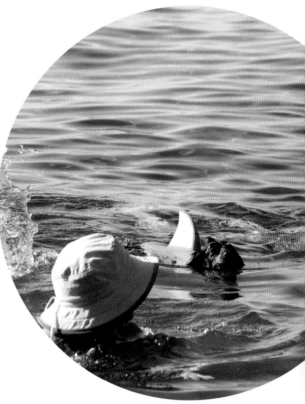

. . . And I am easily inspired by tales of pirates.

"*Oh, oh,* can I fire it at one of those ships out there?" I asked Dad.

"Of course not, Crusoe," Dad replied. "That's just cruel, and this thing is too old to fire anyway." Tired of my silliness, he walked away.

Luckily, a pirate always has a lighter and a fuse on him, so I pulled it out and lit it up.

KABOOOOOM!!!

To everyone's surprise, the cannon fired, sending a cannonball careening out over the sea and directly into the hull of a small schooner, which subsequently sunk; the survivors flailing helplessly in the rolling sea.

I pulled out my telescope for a closer view. I was shocked to see Sharkwiener was already upon them.

"Crusoe! What did you do?" Dad screeched in horror.

"It was an accident!" I rebuffed. "Technically, I didn't actually expect it to fire!"

So, having been deemed responsible

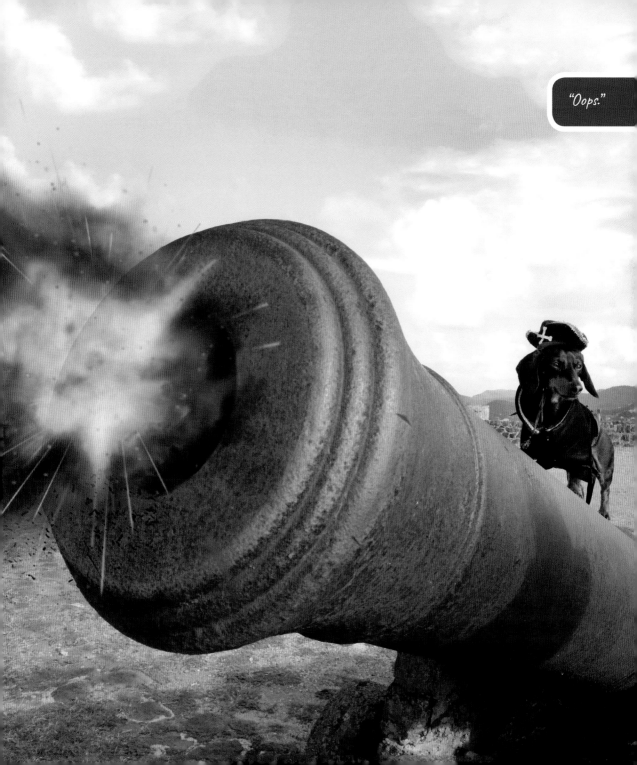

"Oops."

for at least a dozen lost souls, I needed to lighten the mood and take a load off my mind.

"How about a plantation tour?" I asked. So, Mum and Dad took me to the Morne Coubaril Estate Plantation, where they walk you through the process of refining and making cocoa, used for chocolate.

Dogs can't eat cocoa or chocolate, but the guide was kind enough to chop me open a fresh coconut, which is heckin' DELICIOUS!

Later, while walking through a picturesque fishing village, I was *hounded* by some of the local kids who had literally never seen a wiener dog before.

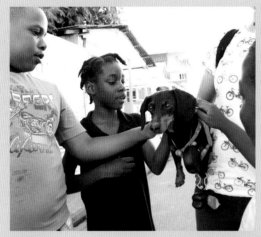

It seems even when I go unrecognized as the celebrity I am, I still get swarmed purely for my comical good looks! Thus is the life of a wiener dog, I suppose.

Everything moves slow here in the islands, including this lift track that's supposed to take me up to my villa. Sometimes I wish more things in life moved slower. . . .

 Keep wishin',
Crusoe

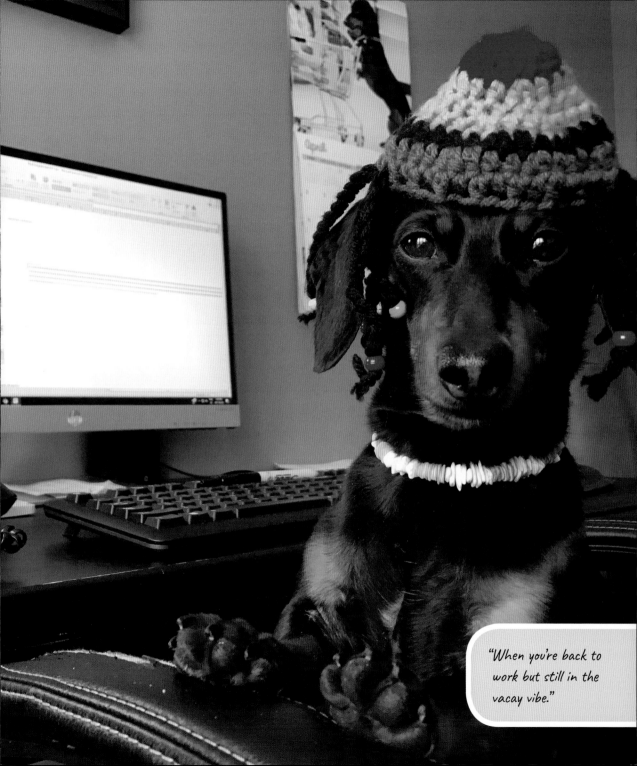

"When you're back to work but still in the vacay vibe."

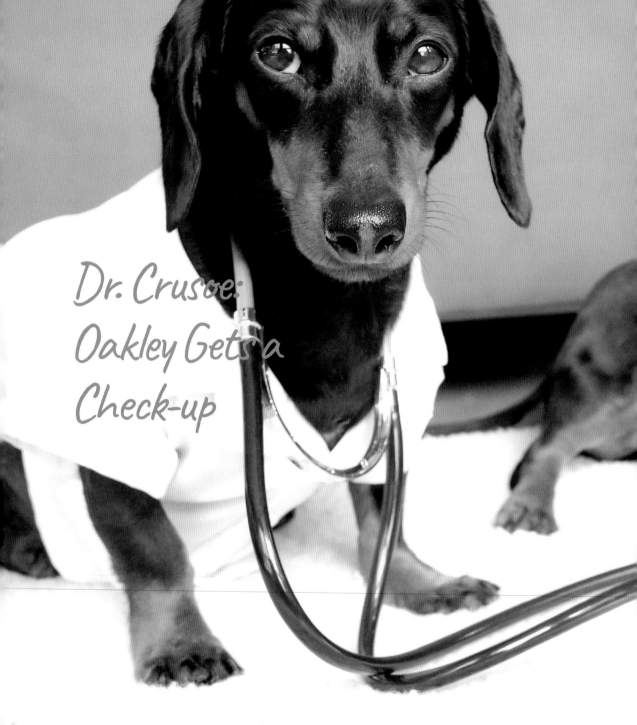

Dr. Crusoe:
Oakley Gets a
Check-up

One day while lounging with my brother Oakley, I asked him if he'd ever been to see a medical doctor before. If he were ever to travel with me, I would need to make sure he has a clean bill of health!

He told me he'd only ever been to see a "vet," so of course I insisted he come see me, *an actual doctor.*

"So, Oakley, if you wouldn't mind diverting your attention from the floor, I would like to start with a few questions on your medical history. I would also like to mention that the tools you see in front of me are top-of-the-line medical instruments, so don't be fooled by their cheap plastic appearance."

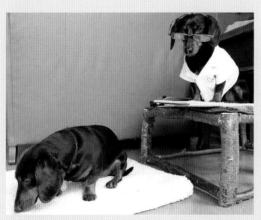

"How would you describe your current general state of health?" I began.

"I think I smell the remnants of a croissant here on the floor. . . ." Oakley said.

I rolled my eyes. "Oakley, answer the question—what is your state of health?"

Oakley thought long and hard, repeating under his breath, "*State . . . state . . . state.*" Then finally he blurted, "What is . . . *Utah*?"

My eyes narrowed in a cold, disdaining look.

"What? We're playing *Jeopardy!* are we not? But please, no more geography questions, I haven't traveled as much as you," he added.

"I just want to know how you consider your overall health to be!" I repeated, my patience waning.

"What is . . . very healthy?" Oakley replied.

I sighed, and decided to move on. "Okay, I'm going to run through a few checks on you," I said. "First we'll check your heartbeat." I told Oakley to keep the metal end pressed against his chest as I looked away to concentrate on what I was hearing. . . .

This was a very peculiar heartbeat indeed. Heck, it sounded more like the tractor I drove on the farm than a heartbeat.

"Next up is the earsnifferscope."

Oh dear, this was very distressing. "Oakley, your ear smells like hamster."

"What does that mean?" he asked fretfully.

Ignoring his question, I used a stick as a tongue depressor to inspect Oakley's mouth. "I'd probably recommend a follow-up visit to the dentist at some point, but for now everything looks fine." I looked at the clock. "Almost done. Last thing, I'll just get your weight on this scale." It took a moment for me to see the number, but when I did . . .

Oh dear. "Oakley, it appears you could afford to lose a pound or two, so I would like to prescribe an exercise program," I said.

"What about my diagnosis?" Oakley asked.

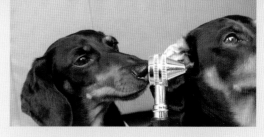

"Well, there's a very real possibility you have Level 4 Hamster Fever, a dangerous condition originating from the interior jungles of St. Lucia. No idea how that reached you here, but I'll give you some meds for it. In the meantime, I have the perfect workout program for you."

"What's that?" he asked.

"Cutting the grass. It does wonders for the buns."

"I guess I could do that," he replied.

However, what I didn't tell him was that I rigged up the height of the lawnmower extra-high.

Keep prescribin',
Dr. Crusoe

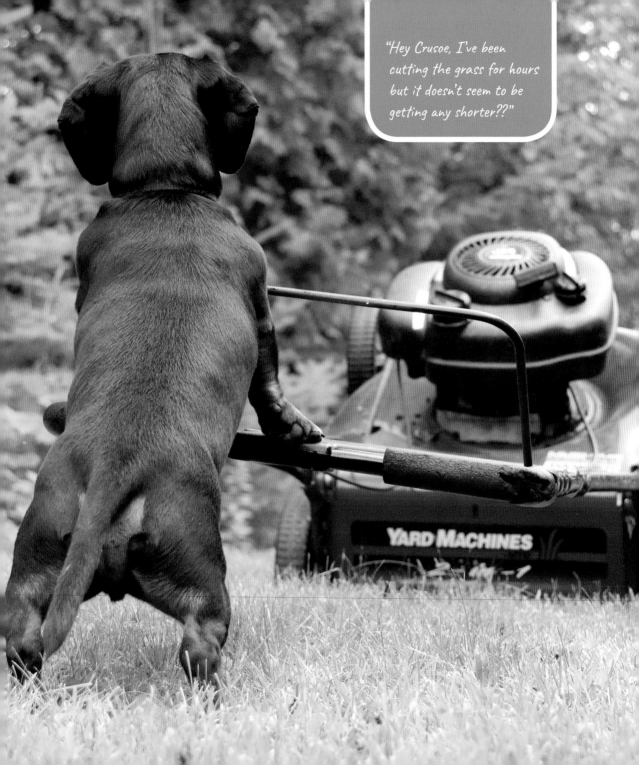

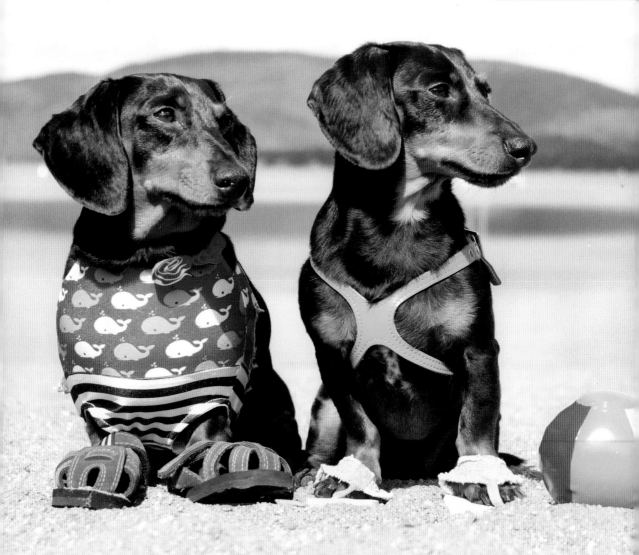

"Bro, be cool, be cool. I think they're checking us out."

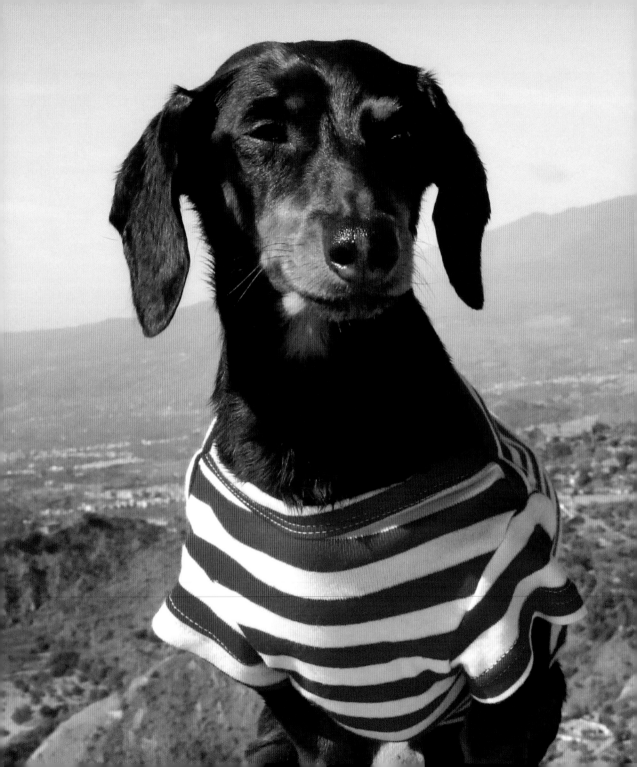

Taormina, Sicily, Italy

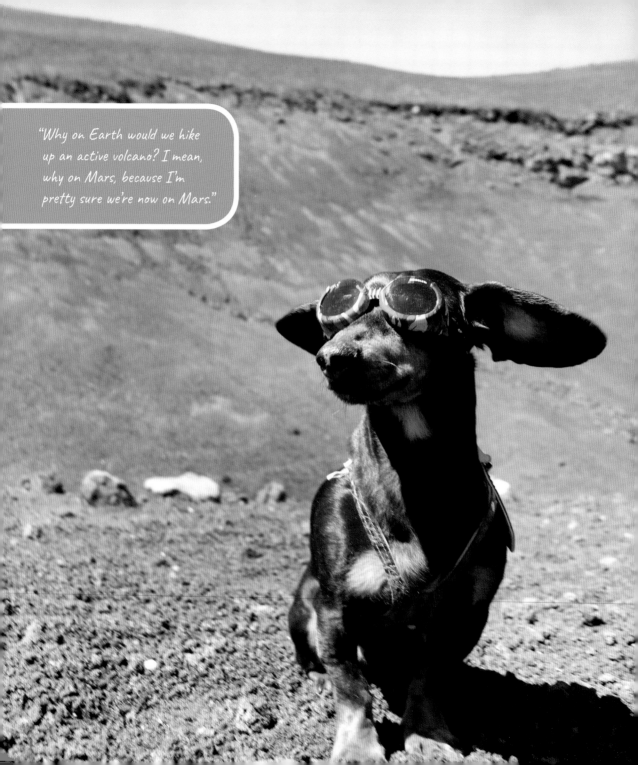

ARRIVED TAORMINA SICILY

When they call Sicily the island in the sun, they sure as heck aren't kidding. This place is scorching, sometimes reminding me of Africa (I've never been, but can imagine).

Yet, it's incredibly beautiful, especially with a view of one of the world's most active volcanos right from your villa!

"Are you sure we should be staying this close to an active volcano?" I asked Mum and Dad.

"Good question," Dad replied, unsure himself.

And you know what they say about escaping volcanic eruptions—you don't. The only tip I can give you is that when you're about to be inevitably engulfed by a pyroclastic flow, throw a killer pose so you'll be frozen in time in the most memorable way possible.

(Not exactly how I envisioned my own statue, but I'd take it.)

As you can imagine, I wasn't too keen when Mum and Dad said we'd be going *up the volcano.* . . .

Why on earth would we do that?

Closer to the top, Dad carried me in my sling bag. Here we are at the crater, and just behind us is a gaping hole to the planet's rumbling underbelly.

Why the heck I have trusted my life around the shoulder of someone as

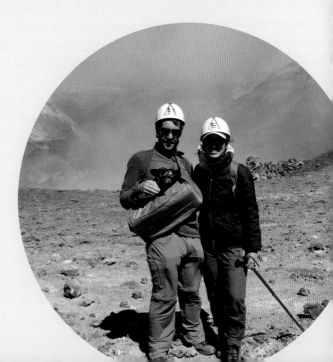

clumsy as Dad is a major question I'm asking myself right now. . . .

Back in Taormina, I just had to try the famous Sicilian dessert; the cannoli. So, we visited Roberto's Loboratorio Pasticceria where Roberto himself gave me an up-close demonstration of how he makes each cannoli on the spot.

I generously offered to stick around for the afternoon to help him taste-test each one before serving to customers, which he quickly accepted.

Yet, I never even got past taste-testing the first one because my verdict was always that, "*Hmm,* this one needs more filling. . . ."

Walking down the cute narrow streets, adorned with potted plants and baroque style balconies and arched street lamps, we came upon an archaeological wonder—the Greek theater!

*"That's better. Now let me check it again— *lick lick lick*—nope, needs more filling still."*

To think that this was built by people thousands of years ago and still to this day hosts theatrical performances is nothing short of incredible.

What was even more incredible was my performance in the lead role as the Greek ruler, *Cruxander the Great,* in that evening's play. Any role as ruler, king, spoiled prince, etc., comes quite naturally to me.

Mum and Dad even got well-fitting background roles themselves as lowly servant and stable donkey, respectively.

We also went to the notorious Bar Vitelli; shooting location of *The God-father.* You might be wondering why there wasn't a crowd of people ogling at my cuteness all around, but here everybody knows, you don't stare at the doxie mafia for too long. I know a couple ruff pups who'll chew your ankles up and dig you a hole real quick.

(Mainly just because they love diggin'.)

Sicily is beautiful, and in fact, Italy as a whole is one place we'd return to again and again.

Keep starin' (and you'll see what happens!),
Crusoe

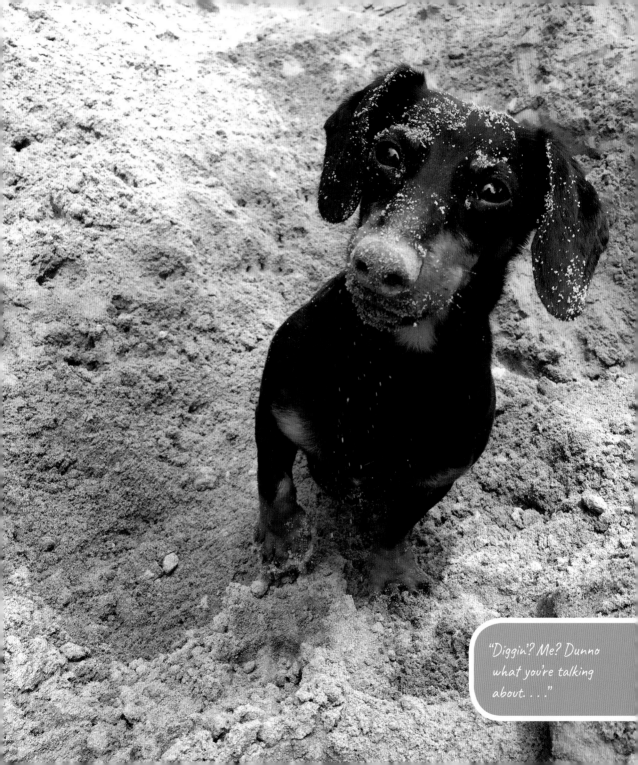

"Diggin'? Me? Dunno what you're talking about. . . ."

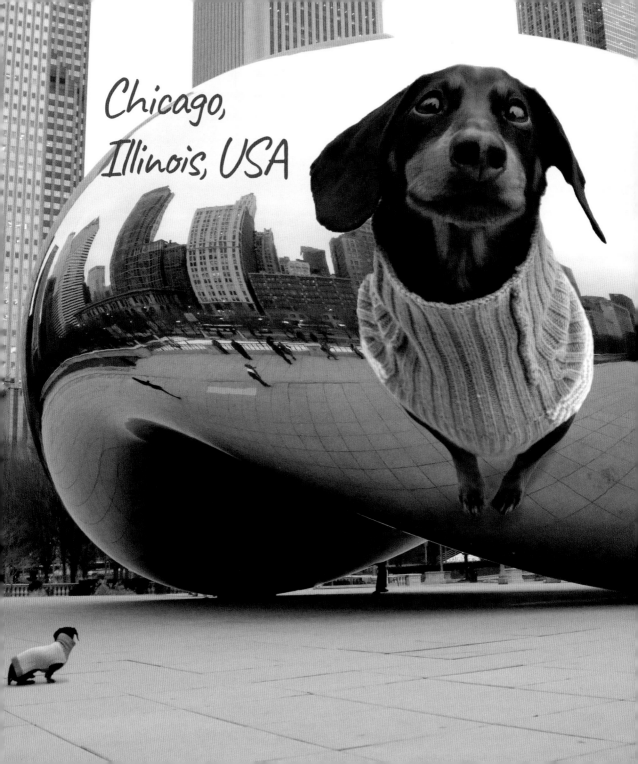

Chicago,
Illinois, USA

CHICAGO
USA
ARRIVED
ST OP OVER

Chicago is well known for its hot dogs of course, but also its architecture.

On the river tour, the guide pointed out several interesting buildings, including one with a gold-plated spire and one with an airship docking station atop of it (whatever that is). However, these old-world luxuries reminded me that I should check on the shipping status of my marble block.

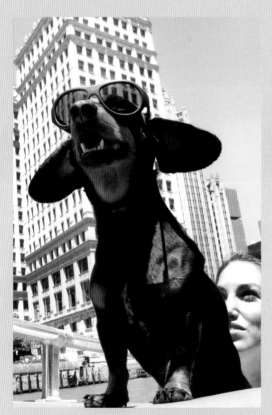

As a joke, I screamed, *"OMG, WIENERZILLA is attacking the city!"*

Most people just laughed, but I did manage to scare the HECK out of a few Japanese tourists standing nearby. One of them might've even had a heart attack.

As a doctor, I better go take a look.

Keep prankin',
Crusoe

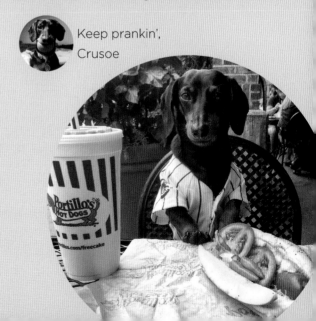

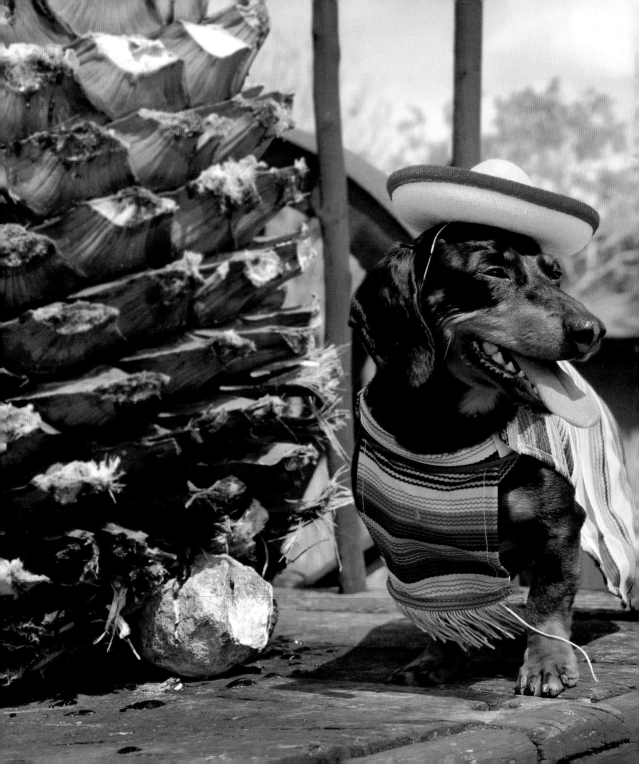

Tequila Farm, Yucatán, Mexico

TEQUILA FARM
MEXICO
ARRIVED

Although I wasn't staying in the typical tequila producing regions of Mexico, I needed to visit the only farm in the area, the Mayapan Traditional Agave Distillery.

Since I hadn't indulged in alcohol since 1999, I was admittedly quite ignorant on the subject of tequila production, so I reluctantly agreed to follow along behind the guide for once.

"This just looks like a bunch of desert cactus," I remarked once we got there. "Where's all the tequila trees?"

"It comes from the agave plant, which is commonly misinterpreted as being a cactus," said the guide. "BUT, the parent plant family of the agave are called 'succulents,' which cacti are also a part of."

I ran through the relationship in my head. *Same parents as cacti . . .* *means it's a sibling of cacti . . . means . . . it's a cactus.*

"That's not—"

But it was too late. Once a dachshund makes up their mind about something, not even the most convincing tour guide can change it.

I was clearly testing his patience, which I delighted in, given my resentment of not being the leader that day.

I plopped down on the ground with a big smile on my face as he continued his explanation on how the agave plant goes from harvest to fermentation into alcohol.

Fermented cactus juice, I thought. Even better.

Then it was time to head inside to try some for ourselves. *Yay.*

So, they gave me a small sampler shot. I was about to be honest and tell the man that it tasted a little better than gasoline and a little worse than what I imagined fermented cactus juice would taste like, but I couldn't offend the hardworking man, so instead I replied, "Sign me up for the circus! Because I can breathe fire!"

He laughed and nodded, saying *"Good, good,"* as if that was the desired outcome.

He went on to explain that a true connoisseur knows how to enjoy tequila straight, but that it is a (harshly) acquired taste mastered by few.

So, I told him I'd take a bottle of his finest. Not sure there's enough years left in me (or the universe) to ever be able to fully appreciate it, but hey, I'm sure Oakley will love the idea of breathing fire for his Game of Thrones cosplays!

Keep testin',
Crusoe

Disclaimer by Mum:
Crusoe did not actually taste tequila.

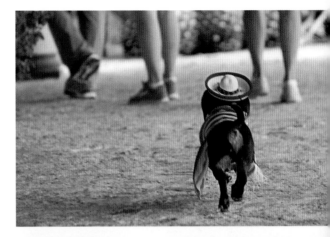

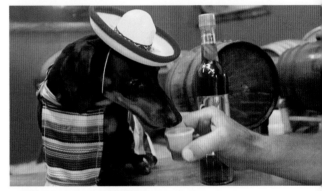

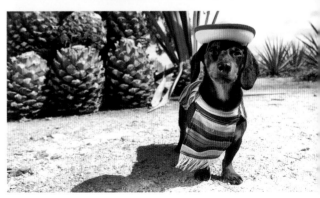

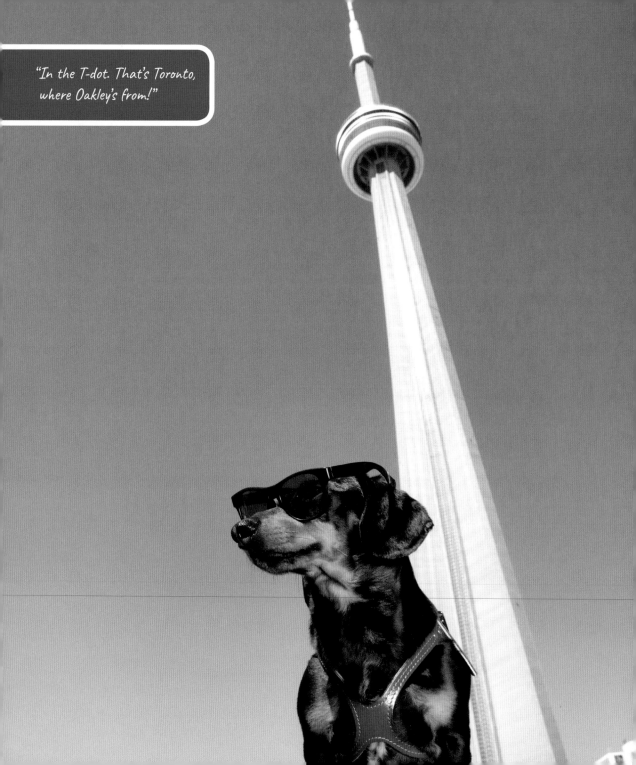

"In the T-dot. That's Toronto, where Oakley's from!"

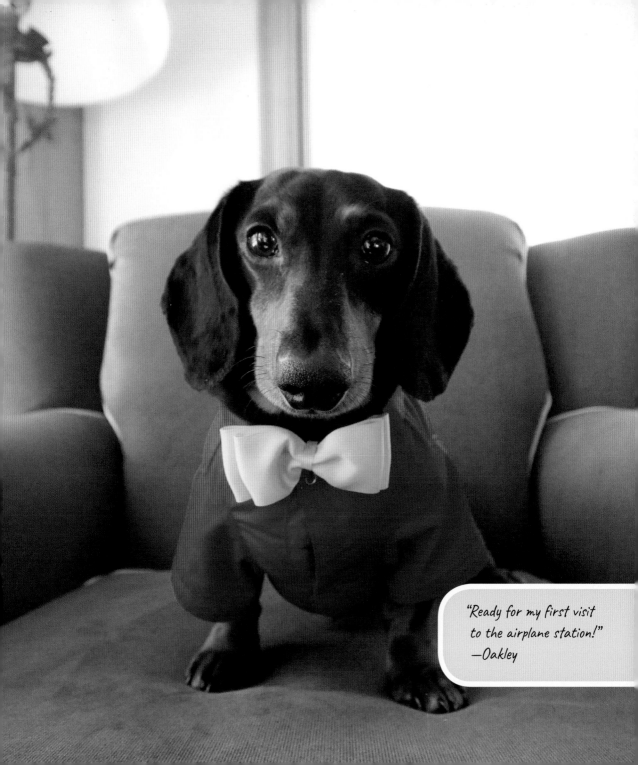

"Ready for my first visit to the airplane station!"
—Oakley

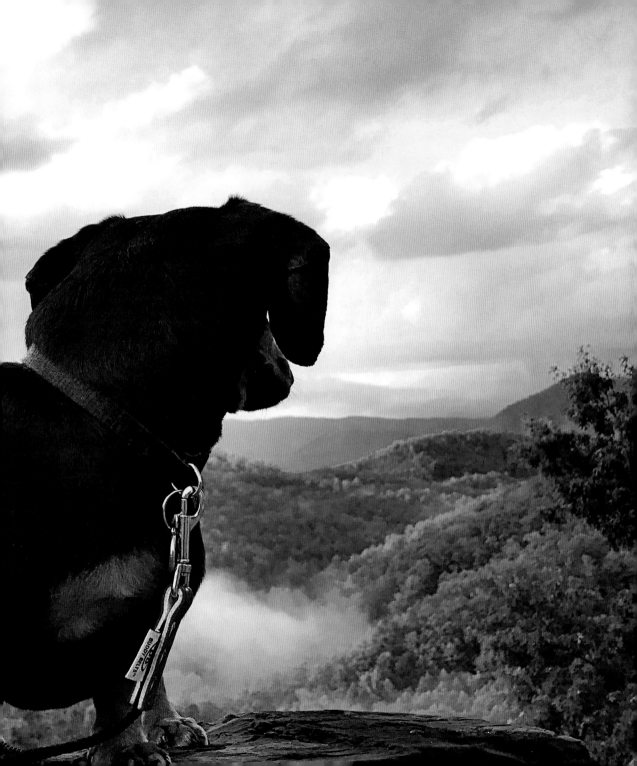

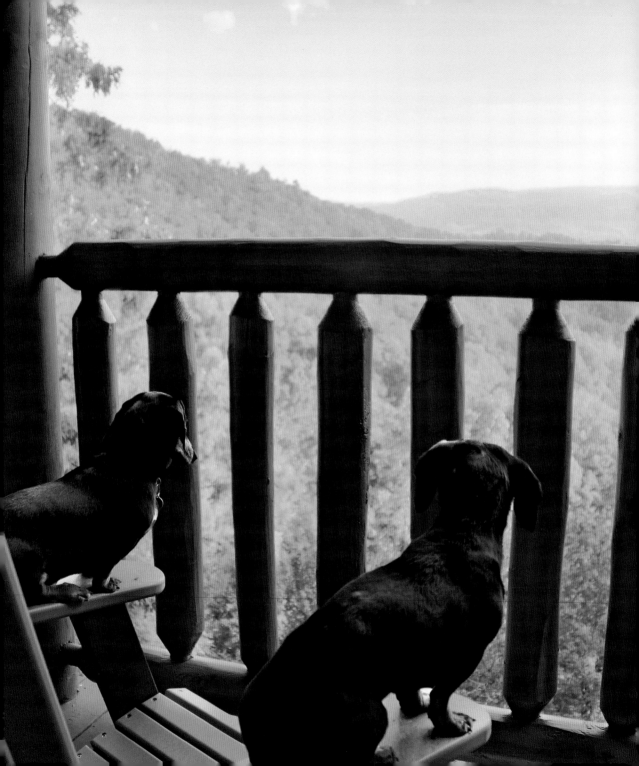

"It's called an airport, Oakley, and don't worry, it's not as scary as

you think," I told him a couple of nights before we were supposed to fly out together.

It was to be his first trip out of the country and his first time on a plane. As he lives with

the parents of my parents, I would only be arriving at his house the day before our flight,

so I had to text him a list of what to bring. Yet, I should have known it wouldn't be so easy.

"Oakley, how old is this suitcase?" I exclaimed as I laid eyes on the antiquated piece of luggage.

"Uh . . . what is . . . 1984?"

"Oakley, don't start with your *Jeopardy!* nonsense. Just tell people it's retro so you can pass it off as fashionable. Now, what have you got in here anyway? It won't close properly."

"Yes, I figured you could help me fit it all, but I assure you, everything is absolutely essential."

I began to rifle through the contents. "Your iFetch machine?"

I asked. "Why don't you just bring a ball and have the humans throw it for you?"

Oakley seemed perplexed. "I guess that *could* work."

"And only a single pair of undies?"

His eyes lit up with his bright idea. "I switch them inside out every day, so I'm never actually wearing the same pair I wore yesterday! Pretty smart, *huh?*"

I just shook my head.

"And what if they don't have donuts where we're going?" Oakley demanded.

"And a whole box of Fudgee-Os, and donuts?!"

"Oakley, we're going to the *United States*. Trust me, there are TOO many donuts and cookies there."

"Oh good!" Oakley replied, gleefully. "Then I can eat a couple of these now."

The next morning, we arrived at the airport bright and early. Oakley, who had been feeling optimistic the night before, was now overwhelmed, especially when we arrived at the beeping, hectic security area. "Don't worry, little bro," I reassured him. "It's just a simple security process."

As we began to go through, Oakley's mom placed him on a tray, which, unbeknownst to her, began to roll along the bars. Oakley gazed around, trying to figure out what was happening, but when he spotted the trays disappearing into the foreboding metal box up ahead, he exclaimed in horror, *"OMG, Crusoe, I'm on some sort of factory conveyor belt!"*

"It's okay, Oakley!" I shouted, but my reassurances were lost in the clamor.

Oakley was really panicking now, almost in tears. "CRUSOE! *HELP! I don't want to be made into packaged hot*

"Oakley! Can you keep that tongue rolled up? You're stinkin' up our aisle."

dogs! PLEASE!" But then, his mom swept him up just in time.

"Oakley! Relax, it's okay, this isn't a hot dog factory. The machine just scans your belongings," I said when I caught up to him.

Once aboard the plane, Oakley was looking nervously around in anticipation of takeoff with his paws and tongue hanging about, huffing his breath all over the place.

I was worried he would have a panic attack during the flight, but he did surprisingly well, and when we finally landed he squeezed his face out of the bag, looked at me, and said, *"Crusoe, we made it! I'm alive! Did you see me? I did it! I fly on planes now!"*

We were both contented to be on firm ground again, but even more so to finally arrive at our cabin in the woods. Now this is a doggone vacation spot!

"So, what do you want to do?" Oakley asked.

"How about river rafting?" I replied.

"That sounds much too exciting

for me. I couldn't do anything like that. . . ."

"Oakley, don't you remember? You fly on PLANES now."

"That *is* true. . . ." he said, pondering it over.

So, we visited Smoky Mountain Outdoors, where we were given special permission to come aboard, under the one condition that we brought our own helmets.

"Now, first rule, always keep your paws inside the boat," began the guide on the bus ride over to the launch point. "Second rule, do not pee in the boat. Third rule, no snacking in the boat."

Oakley shot me an uneasy glance. "I hope this isn't too exciting or scary, because you know how I have a bit of a loose bladder sometimes. . . ."

I brushed it off and told him *he'd be fine.*

Before Oakley could voice any more concerns, we had launched the raft and were swiftly floating down the river. I stood at confident command plotting

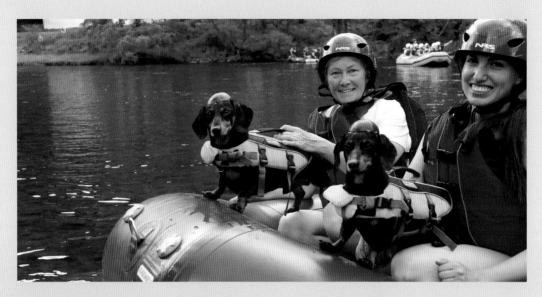

our course ahead as Oakley soaked it all in from every angle.

I noticed a few rocks protruding up ahead, so I looked back at the guide, or rather, *the lowly rower of my ship,* and told him, "Keep fast to *starboard* side, and we'll miss those *rocks popping* up!"

Oakley looked happily around at me, tongue flopping to the side, "Did somebody say Starburst and Pop Rocks?!"

"Oakley, no time for candy right now, we have a ship to steer!"

"I thought this was a raft?"

"Yes, it is, but we're pretending."

"Can we pretend to have candy, too, then?"

I sighed. "Sure," and I heard him whisper a self-congratulatory *"Yesss"* to himself.

I felt proud of my seamanship as we cleared the rocks—that is, until we spotted the first signs of whitewater up ahead. "Okay watch out!" yelled the rower in the back. "You might get a little wet here!"

Wet!? Nobody told me I would get wet!! I quickly

retreated to Mum's arms as we toppled over the rapids. A surge of water swept over the bow, splashing Oakley in the face, and yet he still smiled like a doofus the whole time.

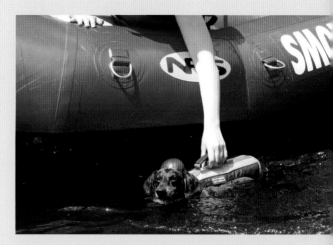

Phew it was over, but I couldn't help being a little ashamed of my reaction.

"I HAVE TO GO TO THE BATHROOM!" Oakley shouted randomly. So, his mom promptly placed him over the side.

"Much better," he said. "Hey, that wasn't so bad after all!"

I just kept quiet.

"Let's go to The Island," I said afterward. The Island is in the center of town and is like a little theme park with rides and candy—

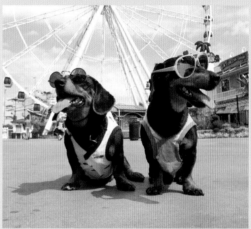

"Candy? *For real this time?*" Oakley blurted. "Let's go! I haven't even had a single donut yet!"

So, there we were, in the heart of The Island, ready for some fun.

"I think you'll love the Ferris wheel!" Mum said. "It's really exciting."

I should have known it was a trap, though. All she wanted to do was smooch me at the top like a high school boyfriend.

I pressed the red emergency button to end the ride.

Aboard a little choo-choo train we

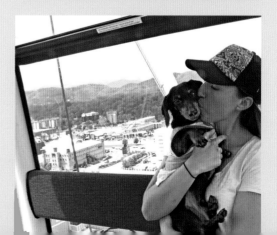

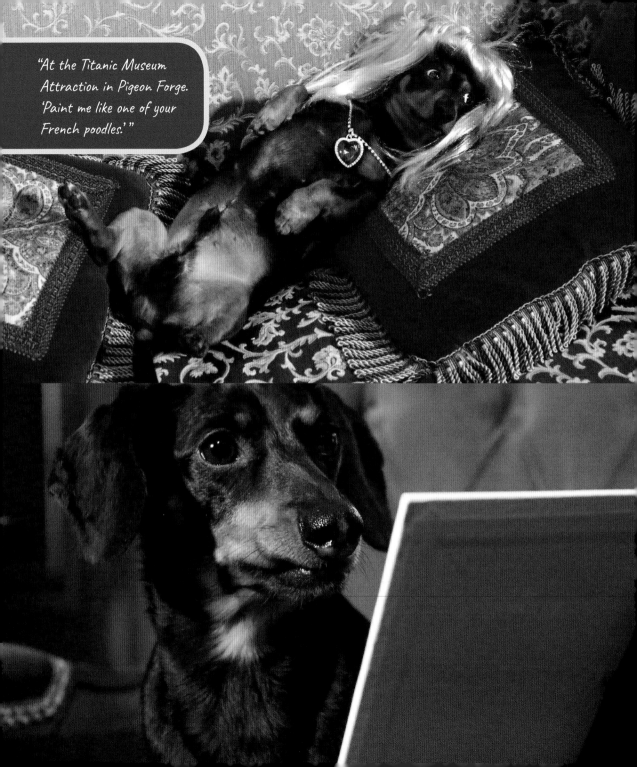

went, taking us on a little sight-seeing tour around The Island.

"Still haven't seen any donuts!" Oakley called back to me. "Are you sure we're still in the USA?"

"Don't worry," I said. "You'll find some soon enough."

That's when I noticed a truly awesome ride I just had to go on! "Stop the train!" I yelled, and we skipped over to the ride, ducking under the fence and hopping up onto the seat.

The bar clicked into place. I was tongue-out excited, whilst Oakley was quietly unsure. "This feels an awful lot like the airplane." he said skeptically. "Except I feel a lot less secure in here. . . ."

"More like a rocket ship," I said, to which Oakley's expression squished into that of a worried prune. However, the lift attendant came running over to us just before the ride was about to start, telling us we couldn't ride it because—get this, *we're too short!*

Well, anyone who knows dachshunds knows that for such "small" dogs, we can make a "big" scene, which is what I did.

However, as Mum and Dad weren't expecting us to be done already, they were nowhere to be found.

"Where are they?" Oakley asked. "It's almost lunchtime and I'm starving."

"C'mon," I said. "I have a plan."

We scurried away into some bushes where I pulled out two costumes. "We'll pretend we're black bears and go raid a picnic."

So, spotting some carefree picnickers over yonder, we made our approach quietly from behind.

"Alright, on my mark we'll rush in and scare them away," I whispered.

Oakley was licking his chops in eagerness. "Got it! I'll go straight for their ankles while you bite their faces off!"

"What? *No-no,* we're just scaring them away, not attacking them."

"Oh, okay. . . ." He seemed almost disappointed.

I gave the word and we scampered over to them. They were frightened at first, but then to my dismay began commenting on how *heckin' cute* we were! I'd been insulted enough times that day! So, I gave Oakley the order to go for the ankles.

Luckily, they ran away when they saw Oakley's gaping chompers, leaving the whole basket to us!

Oakley then went for the sandwich. "Wait a minute." He stopped. "This is whole wheat bread. I hate whole wheat bread. And the crust is still on it! *Disgusting.* I'm not eating this."

It was good enough for me, though, so I ate the whole sandwich myself, and just as I finished, the parents showed up. In another stroke of luck for Oakley, they had brought him a donut!

"What, no icing? No glaze? No sprinkles? This is pretty much a donut-shaped loaf of whole wheat bread!" he remarked, ungratefully. "But . . . since there's no crust, I guess it'll do."

 Keep paddlin',
Crusoe

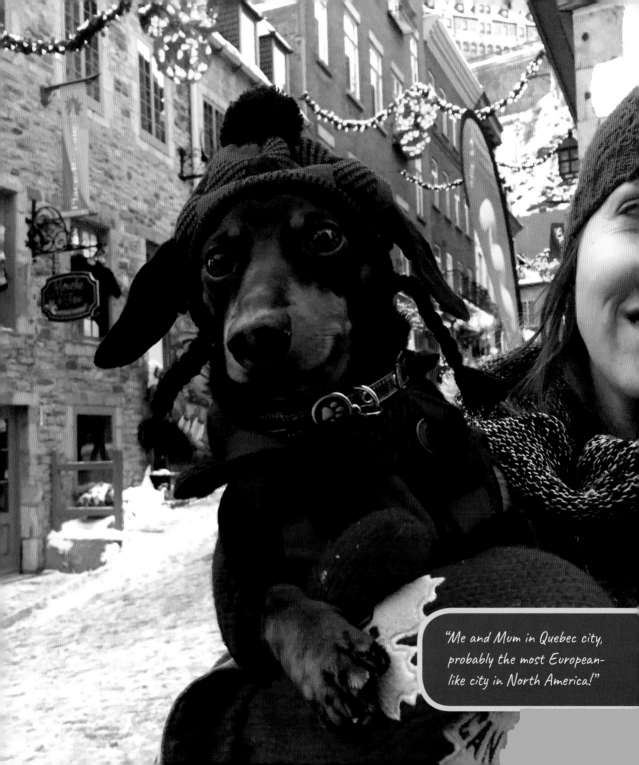

"Me and Mum in Quebec city, probably the most European-like city in North America!"

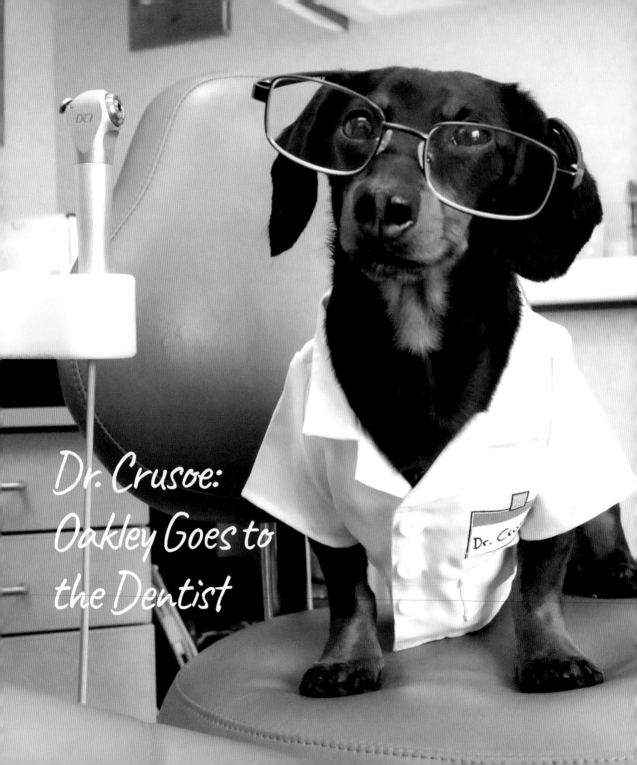

Dr. Crusoe:
Oakley Goes to
the Dentist

Shortly after returning from the Smokies, somebody noticed that Oakley had chipped a tooth. Nobody saw it happen, but it was clear what transpired. With shards of threads still wrapped around the base of the tooth, it was obvious that Oakley had been tearing apart a toy (probably one of mine) when he likely pulled too hard and snapped his tooth.

"What should I do about it?" Oakley asked, worried his famously cute looks could be in jeopardy.

"You should go to the dentist, you probably need a bridge, or perhaps a bonded prosthesis double axel salchow."

"A what?" he asked.

"Oh, sorry," I replied. "I have a habit of employing dental jargon a little too flippantly sometimes."

"Wait—you're a dentist?"

"Why wouldn't I be?"

So, a few days later I was pleased to see Oakley show up at the office.

"Good morning, Oakley," I said, as he hopped up onto the chair. "Just to be upfront, today's appointment will probably cost you a year's worth of mortgage payments, but don't worry, it'll totally be worth it once you have your full smile back again."

Oakley looked a little perplexed. "But I don't have a mortgage."

"Well, I would recommend you not get one for at least a year then."

While Oakley was still deep in thought over what a mortgage was, I asked him to lie on his back so I could take a quick peek in his mouth.

"Will this hurt at all?" he asked.

"Financially or psychologically?" I replied in question. Oakley looked even more confused. You see, the key to being a dentist is being very vague on pain expectations.

"What is that thing?" Oakley said as I pulled out my first tool.

"This is just a mirror."

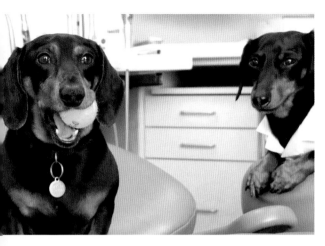

With a bit of mental relief in having a ball in his mouth, he allowed me to peep around without trouble.

"Well, the good news is no cavities," I said after completing my inspection. "You have gingivitis though, so I would recommend brush—"

Oakley cut me off. "Gingivitis?! OMG, what is that?? Please don't say it's an elevated form of Hamster Fever, I'm still on meds for that! Am I going to die?? How long do I have???"

"I'd give you about three weeks. . . ." I said solemnly.

Oakley looked as if he'd seen a ghost, the ball dropping from his mouth and rolling away.

"Just kidding." I laughed. "You'll be fine, just brush more often. Now, we're going to take a look at fixing that tooth

"For what?"

"Oh, it's not for you. It's my selfie mirror to ensure I'm still as sexy as usual." Then I pulled out another instrument.

"And what is that sharp pointy thing?" Oakley shouted, wide-eyed and shaky-voiced.

"Oh this?" I asked. "I just call it 'the sharp pointy thing.' Now open wide and hold very still. I don't have opposable thumbs and I have to pay extra malpractice insurance for that, so I don't want any mishaps here. . . ."

Oakley was wriggling like a piece of cooked spaghetti, and every time he opened his mouth, he'd close it again in trepidation. So, I reached into my drawer and stuffed one of my tennis balls in his gob.

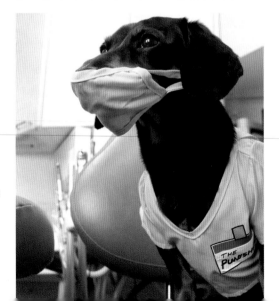

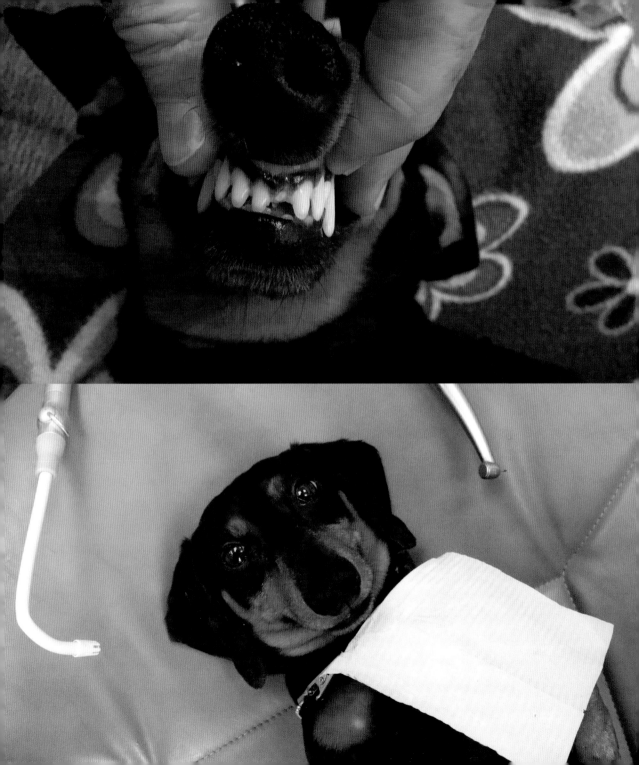

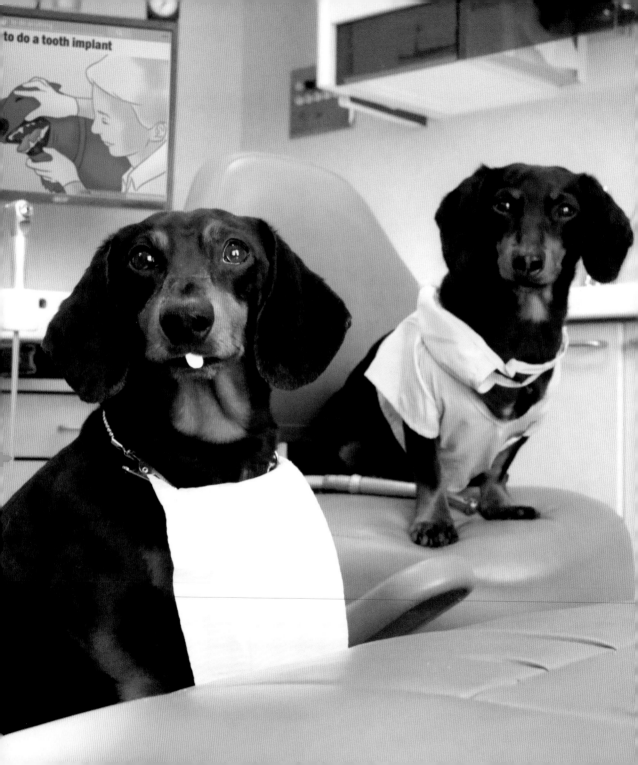

of yours. I just need to go change into my surgical scrubs, I'll be right back."

When I hopped back up onto the chair, Oakley once again was horror-struck.

"Why does your nametag say *The Punisher*?!" he demanded.

"Oh." I looked down at my tag and chuckled. "Haha, whoops. That's my cosplay nametag for Tuesday nights . . . I must have mixed them up. Don't worry about that."

I had Oakley lie on his back again. I then pulled out something with a long cord attached to it.

Oakley gaped at me from below, and I answered his question before he could ask it. "This is an industrial-level diamond drill that can cut through any material on earth. It hurts a little more than a typical dental drill and a little less than a tile saw. So, just hold still and I'll begin—"

Yet, before I had even finished my sentence Oakley had passed out from fear—which in fact was my whole intention. I didn't even need the drill for this procedure, but showing it to patients almost always knocks them out, which makes it so much easier to perform my work and saves me a ton of money on laughing gas.

When Oakley finally awoke, I handed him the selfie mirror. "Look Oakley, you have a beautiful smile once again!"

He stared at himself in disbelief. I couldn't tell if he was thrilled or disappointed. Finally, he exclaimed, "Wow! I must get me one of these selfie mirrors! I've been missing so much! I've been looking at myself in the reflection of my water bowl this whole time, but this is great!"

"Yes," I replied dully. "I like mirrors, too, but how do you like your new tooth?"

"Oh, I forgot!" he said. "It looks great, just like it did before. *I think . . .*"

"Even better than before," I said with a wink.

"Can I keep the selfie mirror?" he asked.

"Sure."

So, that wrapped up Oakley's first visit to the dentist. He did great for his first time, but I think we should really all take a moment to admire my textbook example of a perfect tooth bridge salchow triple axel crown.

Until next time . . .

 Keep brushin',
Crusoe

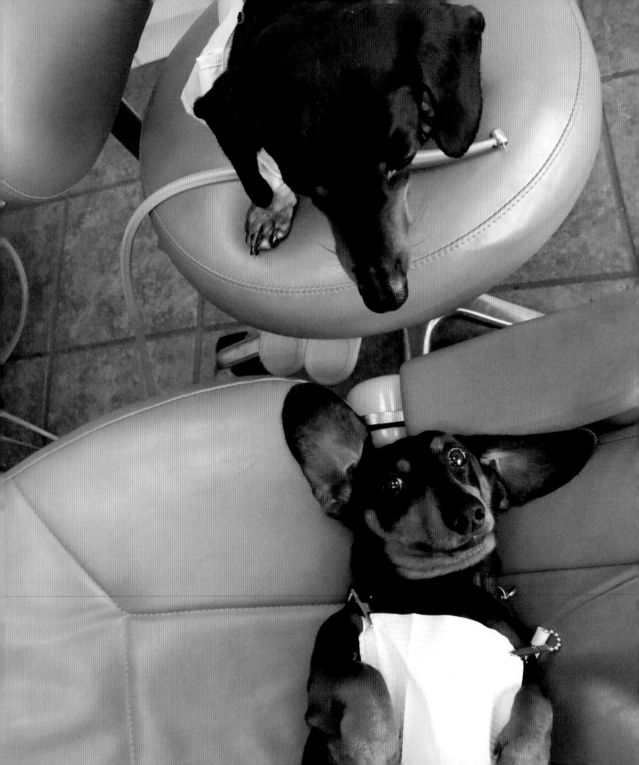

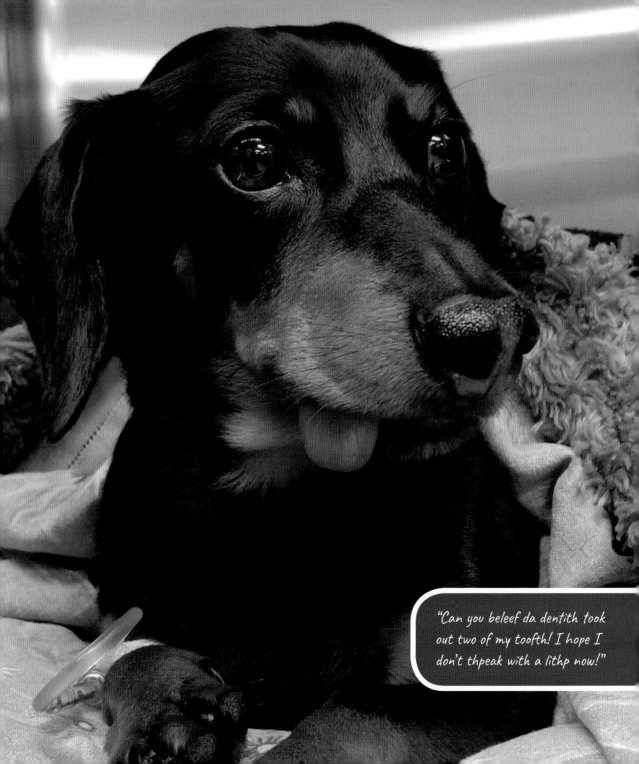

"Can you beleef da dentith took out two of my toofth! I hope I don't thpeak with a lithp now!"

My Midlife Crisis

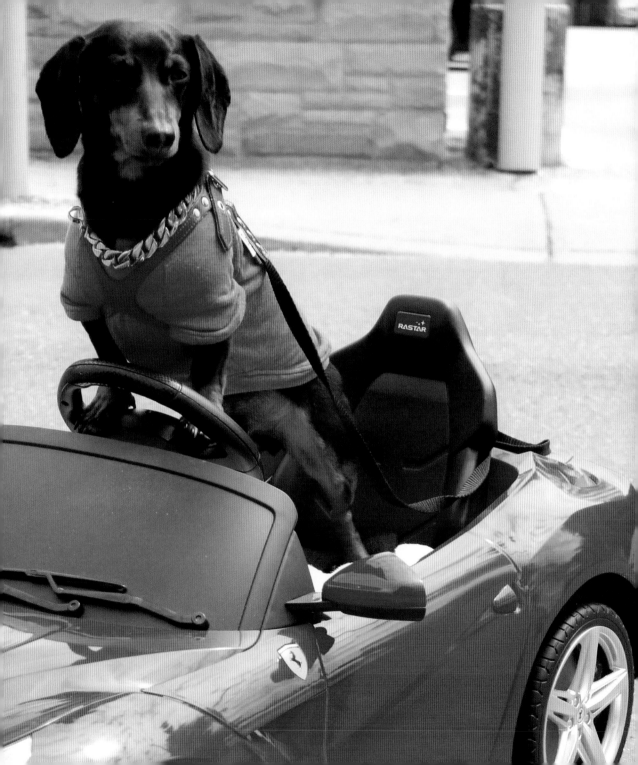

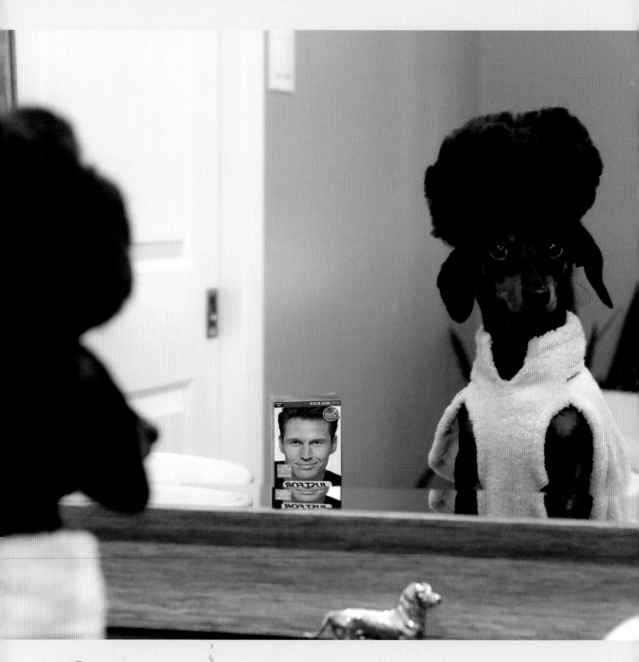

By the time this book comes out, I'll be almost 9 years old (October 28 is the date in case you'd like to send me presents). That's 63 in human years, well over the hill. It doesn't help when I look at Dad, who is only 30 and already wears grandpa-style house shoes, a plaid robe every morning (not always with something

underneath), and generally prefers to hang on the couch with his dog than go out on Friday nights. So, I especially worry I'm on track to end up like him.

Which is why I had to buy a fancy one-seater sports car; not to make myself feel better about anything, but to physically distance myself from Dad. "Sorry, there's only room for me. . . ."

However, I have noticed some of the changes that are happening to me as I get older. Since I check the mirror so frequently, I am well aware of a few gray hairs developing on my chin, and my ears have a few of those random, extra-long, old-man hairs, which Dad wants to trim but Mum says are cute. *Can't I decide for myself?!*

So, I zoomed over to the pharmacy in my Ferrari and picked up some Just for Men hair color. However, I must have misread the package, for it was evidently some sort of monstrous afro growth formula!

I better toss this out before Dad accidentally uses it himself—Mum already complains about his hairiness as it is!

One day when Oakley came over, I was surprised and *absolutely delighted* to see he has gray hairs all over the top of his head and his muzzle! And he's *a year and a half younger*! I took a guilty comfort in that, but I'm sure he's never even noticed it himself!

Anyway, you're only as old as you feel, right?

So, I guess I got the good genes on the hair side of things, but as you'll later see, not in everything. . . .

Keep growin',
Crusoe

"There's one in every family. . . ."

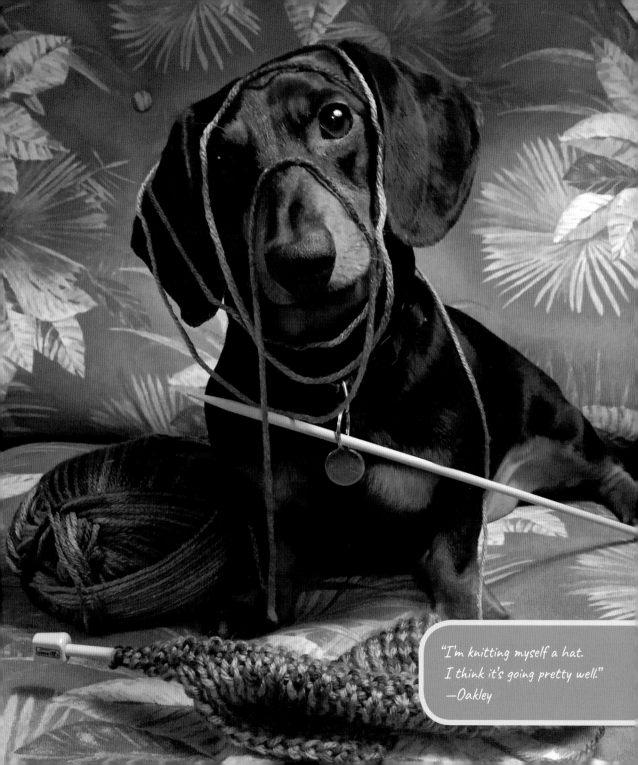

"I'm knitting myself a hat.
I think it's going pretty well."
—Oakley

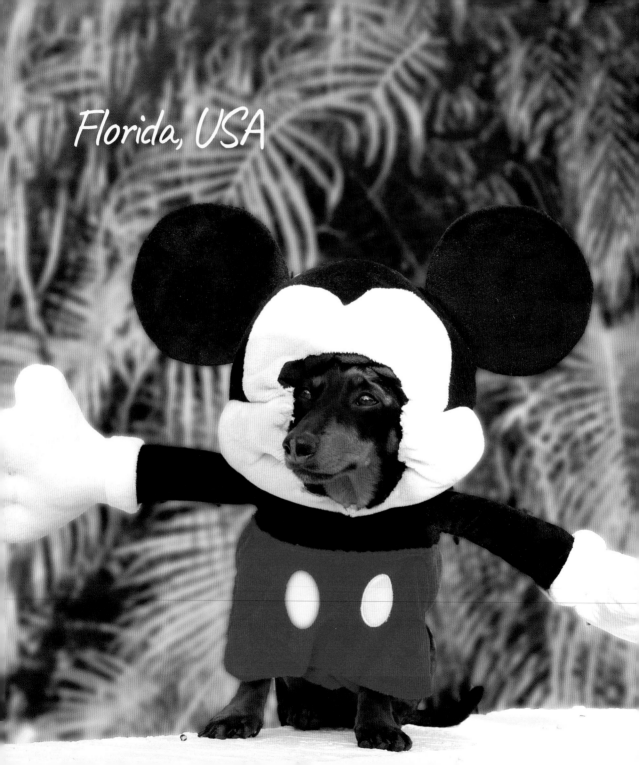

Florida, USA

FLORIDA
USA
ARRIVED

I've been going to Florida since I was a pup. Nowadays, I spend one to two months there per year. It's a nice warm escape when I need it; a regular ripe supply of squirrels, *guaranteed sunshine,* beautiful beaches, and of course, some great fishin'.

My usual spot is a house owned by my Mum's parents in the little town of Homosassa on the Gulf Coast.

In the sun is how I spend 90% of my time. The other 10% is spent fishin'.

We go out in the shallows of the Gulf, usually for redfish, or whatever else we can catch.

The whole time I'm hanging over the side, tongue flopping down almost to the water. My excited squeals and whines are interminable to the point Mum and Dad say they'll never take me again (but they always do).

I also learn pretty quickly who is the most proficient fisherman aboard, because the order in which I observe and accompany you is based on how many fish you catch. It becomes a sort of unofficial competition among the humans to see who I will stick beside.

Dad always gets offended that he is usually the last one I care to look at, even sticking beside Mum over him, but hey, this is fishing and I've got no time for wimpy feelings.

As you all know well, when that rod starts bending and the line zips out with a fish on the hook, I'm the happiest, most excited pup in the world.

"How does that saying go again? 'Sun's out, ~~buns~~ *wieners out'"?*

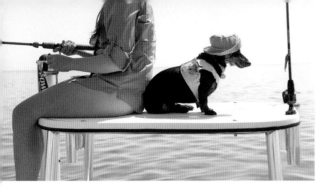

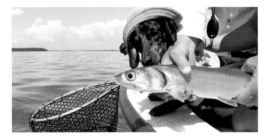

"Alright,
everybody
smile."

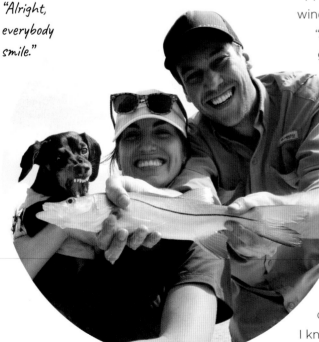

Here we caught a little "ladyfish," as they're called. So appropriately, I gave her a kiss on the cheek, and put her back in—but not before giving her my number and telling her *to tell all the other fish* about how nice it is to be caught by Crusoe.

It's usually not longer than a couple hours on the boat before we bring in a big one, though!

What a day! You can tell I had a blast by that smile on my face!

One morning while in Florida, I had the opposite of a smile when I looked out the window and saw something terrible.

"Just a little rain," Dad had said. I grumbled something under my breath and walked away.

Later that day, I couldn't tell if he was serious or joking when he presented me his homemade umbrella rain suit.

I was skeptical, yet was quite surprised to see it worked.

However, the forecast kept predicting more rain for us, so eventually Dad asked if I'd like to go somewhere else. I wasn't quite sure what he meant, but before I knew it we had packed up the car,

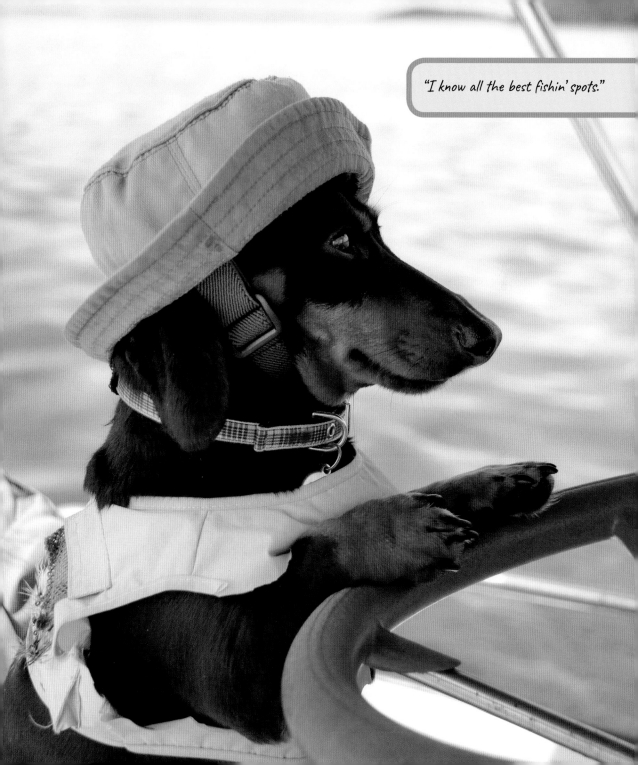

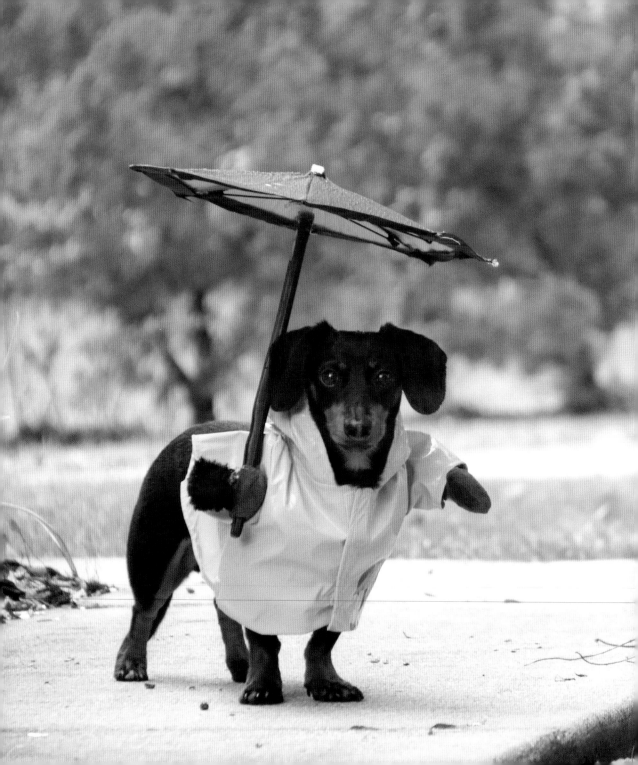

grabbed the keys, and were on our way to . . . *the Keys*!

We rented a cool home on a canal leading out to the ocean.

"How would you like to swim with the fishes instead of catching them for once?" Dad asked me the first morning.

It was a peculiar notion, but I accepted, knowing that Key Largo offers some world-class diving.

You perhaps didn't know, *but could have guessed,* that I'm a fully (self)-certified PADI instructor. So, for all the readers out there, you can also consider this to be an official introductory course.

- The number 1 rule of scuba diving is NOT to "keep breathing." It is in fact, to "keep flexing." Not to get too scientific, but when your muscles are constantly in an uber-tense state, it's impossible for wimpy air bubbles to form in your veins and for your lungs to overinflate. Plus, it will help deter sharks and attract ladyfish.

- Safety stops are wussy stops, and quick ascents are preferred if you can shoot out of the water like a dolphin.

- Do not be fooled by the apparent cuteness of any Sharkwiener. They will bite your face off.

- It is a customary joke to discreetly close your buddy's air tank while under the water. Just wait until you see the hilarious expression on their face before you turn it back on.

We arrived at the reef and descended into the depths. Everyone was so preoccupied with the beautiful fish and reef that no one seemed to get a picture of me underwater!

But hey, I was preoccupied, too—especially with this shark I saw!

Mum, Dad, and Uncle Jack, who between them have dived various places around the world, remarked that the diving here in Key Largo is truly amazing. The reef is one of the most pristine they've (*we've*) ever seen, which is due to the fact these waters have been a protected marine zone since 1960.

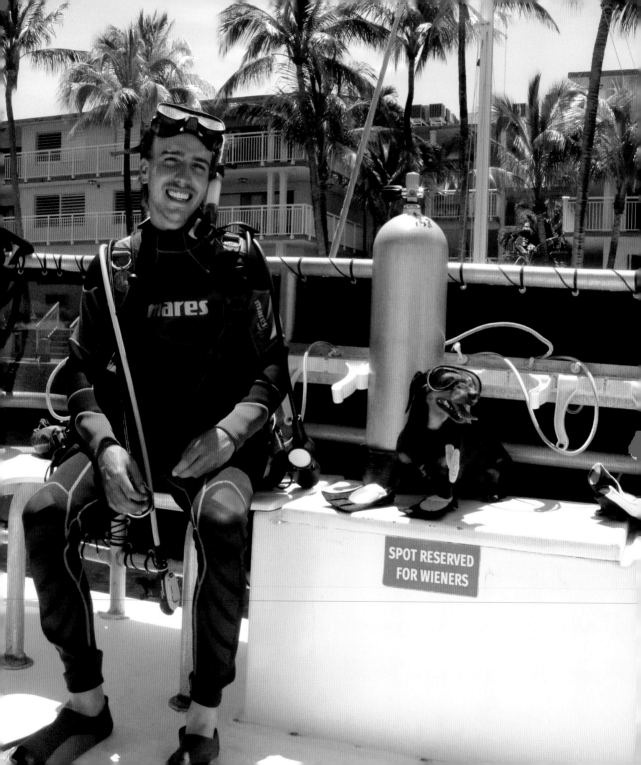

SPOT RESERVED
FOR WIENERS

The next day, we were off to spend one night in the iconic Key West, along the way stopping at the beautiful and dog-friendly Sombrero Beach.

Unfortunately, I forgot my sombrero in Mexico, but I did have my shades!

And YES, that is my TAIL, although I can see how you would be easily confused.

However, my moment of tranquility was abruptly disturbed when I noticed some kids obnoxiously building sand castles just a ball's throw away. Sand castles are not allowed, because they obviously resemble snowmen, which I despise.

Disclaimer by Mum: Crusoe is NOT certified and doesn't know what the heck he's talking about.

Tsk tsk

So, after a nice destructive morning on the beach, we were headed farther south along the single highway, leapfrogging from island to island down to Key West and the "Southernmost Point" in the USA.

We spent the day visiting some museums, some of which even have viewing towers you can climb up for a neat wraparound view out and

beyond. However, peering out with a pair of binoculars, I noticed something terrifying.

"Mum, Dad!" I shouted. "Look, I see a marooned boat out in the shallows, and, *oh my*—it looks like they're being circled by Sharkwiener!"

"Did you have something to do with this?" Dad demanded harshly.

"Of course, not!" I defended myself. "Geez, a guy sinks one ship by accident, and now EVERYTHING'S his fault?! What do I gotta do to catch a break around here?!"

Dad regarded me suspiciously.

Now if you'll excuse me, I need to get going before he starts asking more questions.

Keep ladyfishin',
Crusoe

I've lived in the city for the last five years or so, after having grown up in the country. I've come to enjoy much about the city, like chasing the fat squirrels in the park, digging in the community garden box, sniffing out the fox living under the equipment shed, and barking at all the cute ladies who pass under my balcony. Yet, it was also missing some things. For one, I didn't have a true backyard of my own.

So, with a new home in sight, we sold our condo. I insisted that Mum and Dad let me be the realtor.

Not sure why, but I got a lot of disturbing calls in that process.

We arrived at the new house, and it was breathtaking! It was the perfect country home I'd been looking for; nothing but the smells and sounds of nature all around, encircled by forest with chipmunks darting in and out of blackberry bushes, a rustic gravel driveway. . . .

Until I realized, "What the heck guys?! *No yard? No grass?*"

"The previous owners didn't believe in having a yard," Dad replied. "Whatever that means. . . . But don't worry, I'll build you one."

That was disappointing to say the least, but I didn't have time to dwell—we had boxes to move.

"Oakley, lift with your legs, not your back!"

"But our legs aren't long enough!" Oakley retorted.

Realizing we were not tall enough to lift the boxes off the ground, I devised a better plan of cutting holes in the sides and placing the weight on our shoulders to help slide the box along the floor. I got the preferred position in front.

"Crusoe, did you fart?" came Oakley's muffled voice from inside the box.

"Uh, don't think so . . . ," I lied with a smirk. "I think there's some Febreze back there, though."

We were all happy and excited to have just moved into our new home, back in the country. Yet, there was something heavy weighing on all our minds. . . .

Keep sellin',
Crusoe

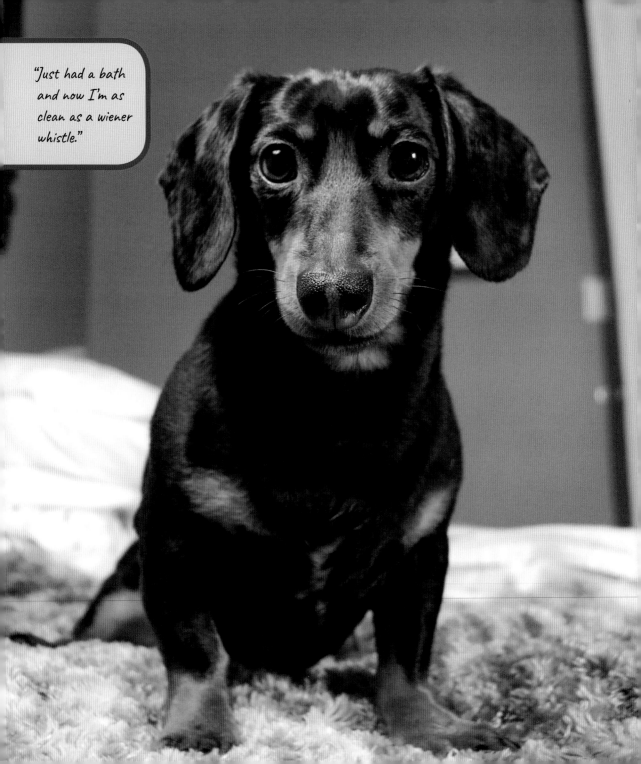

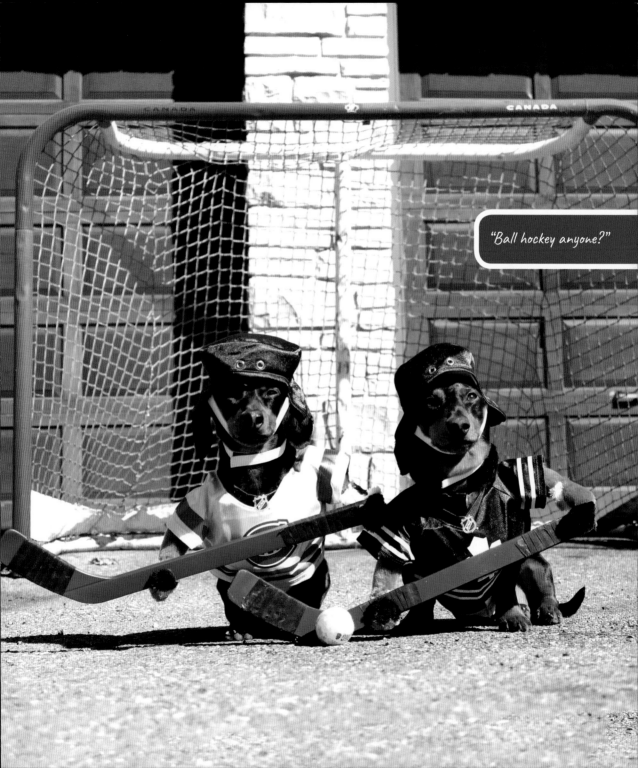

"Ball hockey anyone?"

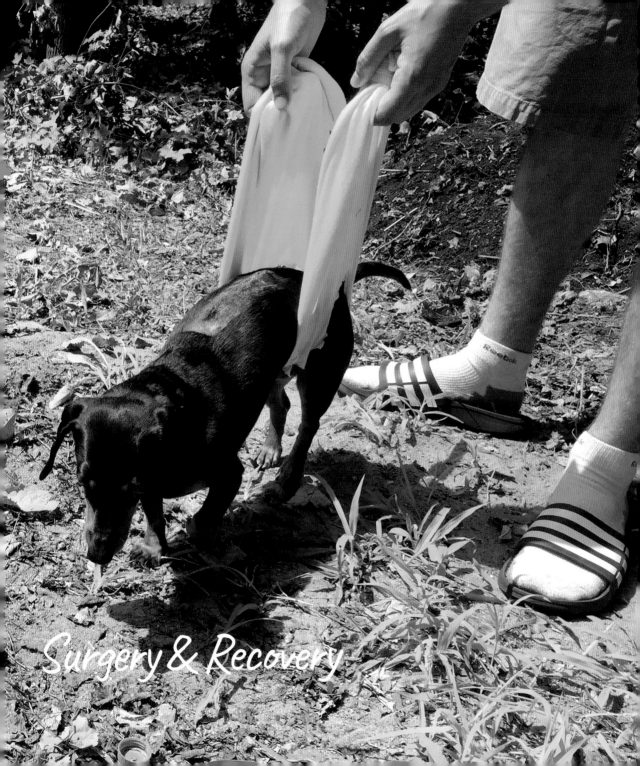

Surgery & Recovery

There's no better way to ground your ego than having to learn to walk again.

That's what happened to me in August 2016, just four days after moving into our new home. I'm blaming Dad for making me carry all those heavy boxes.

Just kidding. We aren't sure exactly what happened, but I do know that one of the discs between my vertebrae burst, causing me to go wobbly in the hind legs (not the late-Friday-night kind), which promptly required surgery to remove the pressure on my spinal cord.

I likely never would have shared such intimate details of my health with you all, but I guess now I have no choice but to level with you. I've experienced very minor back issues for a few years, yet they were always solved with a bit of rest, pain meds, and rehabilitation. This recent episode was different though, because I had never experienced any loss of motor control before, and once paralysis occurs, there is only a 24-hour window to conduct surgery or the damage to the spinal cord is permanent.

And since we're getting

everything out in the open right now, I must admit to Mum that the poop on the hallway floor last month . . . it wasn't Dad. I did it. *Phew* Feels good to get that off my chest.

Anyway, as you can imagine, that was a hard day for Mum and Dad as they drove me to the neurosurgeon.

The worst part of it all is that Mum and Dad have done everything they could to prevent this from the day they got me, building me ramps all around the house and securing baby gates at the top and bottom of stairs.

I still remember waiting in the consultation room, not understanding why I was there, Mum and Dad looking sad. Even my lifelong friend, Laffie, was there to see me off. I was then taken into the hands of a stranger in a white lab

coat as I threw one last desperate glimpse at Mum and Dad, beckoning them to save me. . . .

They didn't. And then everything went black.

I woke up in a tiny cage, my head spinning and eyes blurry, a strange feeling in my back. Something in me had changed, I could tell. I burrowed under my blanket, hiding from the lights and doctors bustling about outside my cage. My first thought was that Dad had elected me for a cool experimental procedure, like implanting me with Wolverine bones. Or more sinisterly, perhaps Mum had sold me to be *a lab rat to test women's cosmetics*?!

I was so relieved when Mum and Dad finally came to pick me up forty-eight hours later. Once we hopped in the car, a quick look in the rearview mirror revealed no lipstick on my face, so that was good.

The reality of my situation seemed to kick in the next day when the stronger medications wore off and I came to understand that I couldn't yet walk; that I could barely turn around in my crate; and the embarrassment of wetting my bed. It hit me that this was going to be a long, hard road to recovery.

I couldn't do much at all to begin with,

just hanging out in my crate all day except for quick potty breaks. Although, the doc did prescribe me all the gentle squeakin' I wanted!

Which made me wonder, *Is it possible to overdose on squeaking???*

Now I finally knew how my Mum felt, and I guess we have one more thing in common. You see, my Mum was in a terrible car accident about twelve years ago. She shattered two vertebrae in her back and now has metal plates supporting her spine. She spent an entire summer in the hospital, two months of which were in intensive care. She's gone through everything I've gone through and worse, including learning how to walk again.

"I hope I can be as strong as you were . . . " I told her.

"I know you will be," she reassured me, with a tear in her eye. "You're my baby after all."

Normally I avoid her kisses for the sake of my maintaining my manly image, but those days, I admit they were all I wanted. . . .

Learning to walk again would require the use of a sling to support my back end, which of course Dad decided to construct himself. Knowing his fashion sense, I should have known what a bad idea that would be.

"Dad, did you literally model this off of Borat's mankini?!" My fans will never be able to look at me the same!

Still, I wasn't ready for walks yet, so all I could do was watch Laffie from the

"Hey, watch what you're pullin' on back there!"

"As Dad explained, the laser helps my body accept my new titanium-alloy bones."

"My powers are being supercharged!"

porch and tell her which trees I usually mark. "That one there, over there, *and oh, don't forget the recycle bin!*"

Four weeks later, I was officially on "room rest" instead of crate rest, which is kind of like going from solitary confinement to a regular jail cell.

Yet, jail cells aren't so bad when you have so many people thinking about you and sending you care packages! In fact, the reaction and support from my fans over this time was mind-blowingly heartwarming.

Mum and Dad truly believe that the fun I had from opening all those packages and letters helped keep my spirits up.

After two weeks, I was finally able to walk on my own, although far from perfectly and only for very controlled amounts of time.

I'd also been watching a lot of TV, including the Olympics, which sparked the bright idea that I would like to win the gold medal in the 100-meter doggy paddle one day.

Yet, between all the relaxing and squeaking at home, I was taking my rehabilitation therapy quite seriously! Here's what I did:

At-home exercises and stretches, to

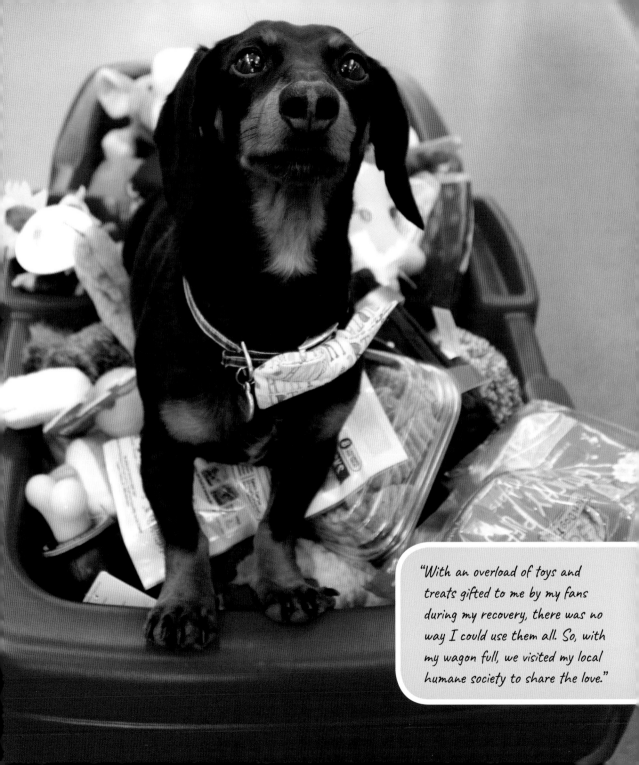

"With an overload of toys and treats gifted to me by my fans during my recovery, there was no way I could use them all. So, with my wagon full, we visited my local humane society to share the love."

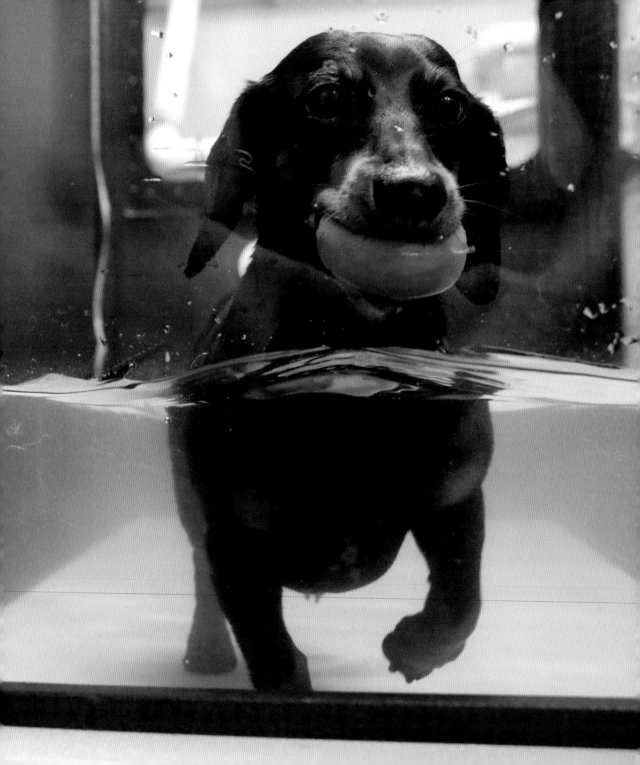

keep the muscles working and the nerves stimulated.

Laser therapy, stimulates blood flow to the area to promote healing.

Electro-acupuncture, helps relax the muscles and alleviate pain so the body can heal easier.

Water treadmill, works a whole bunch of muscles and stimulates the nerves in a variety of ways.

There were times where I just felt like giving up, but I never "dropped the ball"!

After a grueling two months of rehabilitation three times a week, not including everything Dad did with me at home on a daily basis, my therapy team surprised me with a gold medal for my outstanding performance!

I was brimming with pride and relief, and I didn't even have to race Michael Phelps! For a second, I even contemplated the idea of melting it down to use as gold plating on my future statue, but I think this is one for the keepsake pile.

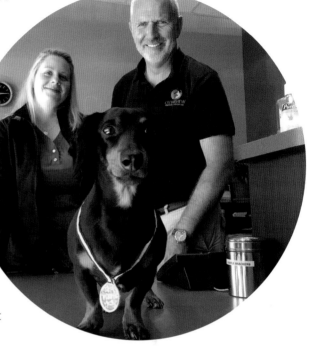

 Keep fightin',
Crusoe

Note from Mum:
Not every dog requires the same treatment, so always consult your vet. Crusoe has a dedicated page for intervertebral disc disease (IVDD) on our website, including all our learnings and experiences on prevention, surgery, rehabilitation, etc., that you may find helpful.

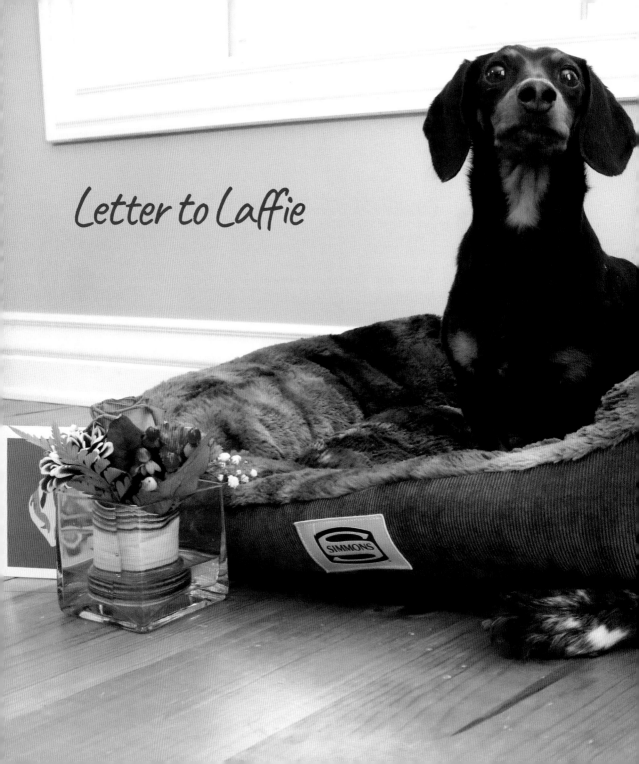

Letter to Laffie

Ryan Beauchesne

It seems life was not done presenting me challenges. After having just gone through surgery, my best friend in the world and lifelong mother figure, Laffie, passed away. . . .

This is my letter to her:

Dear Laffie,

It was just last week that you were by my side, staying with us while your parents were away. By some sort of coincidence, this is when my back took a turn for the worse and I went for emergency surgery. You, the friend I needed most in this time, were there to keep me company as I went off for my operation and to welcome me back home when it was done.

So perhaps it was no coincidence that you should be there with me in this time. You've always been a canine-mother-figure of mine, and I feel like maybe your last motherly act was to see me off on a good recovery course.

Those first couple days after surgery, when I cried in my crate, you came and *slept by my side to give me comfort. I know it made a difference, you being there, so for that I'm thankful.*

I still remember the day I came home as a pup. I was scared and shaking, especially at your towering figure over my little body. Yet, you were gentle and kind, and wagged your tail. You barely even knew me, and yet you gave me comfort and let me snuggle in your warm, woolly fur.

From that day forward, you were my best friend, and although you've always preferred to stay out of the limelight that has found its way to me, it was you who shaped me into the dog I am today.

You taught me how to be an adventurer. Even as a young pup, I quickly took after your free spirit, doing my best to keep up with you in the bush as you followed the scent of your favorite critters.

You taught me the hunter paw-signal, and how to use teamwork to better ambush our quarry.

You taught me how to play, and how to be tough.

You taught me how to withstand our cold winters, and how to move through the snow like a hare.

You taught me how to scratch at things I want, which is one of the cutest things I do according to Mum and Dad, but also one of the most annoying. So, thank you.

Most importantly, you taught me how to be a loyal companion. You were a dog who came and went as you pleased with no leashes or fences, but you always came back (most of the time). I'm happy to have learned that "country dog" spirit from you.

I'll miss sleeping on the couch next to you, and our walks through the woods together. I never told you, but it was sort of nice as you got older and slowed down, because it meant I could finally keep up with you. I'll especially miss sharing in new adventures with you. We had some good times together. . . .

I'm sorry your kidneys failed you. At 15 years old, you were still so strong in every other way. Part of me wishes you could have stuck around a bit longer, but perhaps that is selfish of me. I'm grateful you made it as far as you did, for there were so many other times when you brushed death aside—like when you chased away the black bear who was eating our garbage . . . or when you floated away on a piece of ice on the thawing lake . . . or when you got lost in the woods on a –30°C night, only to turn up the next morning a mile away enjoying breakfast at a stranger's house.

I think life didn't fail you at all. You conquered it, and lived it in a way most dogs would envy. Not many people know about you—let alone your story, but fame was never important to you, and . . . I almost envy that. I may be a celebrity, but you are my star.

Thank you for everything you taught me. I promise I will carry on your legacy. I promise I will get better from this back surgery, and I promise that as soon as I am, I will chase those critters for you. And every new adventure I live, I'll imagine you by my side.

Goodbye my friend. Until we meet again,

 Keep shinin', Crusoe

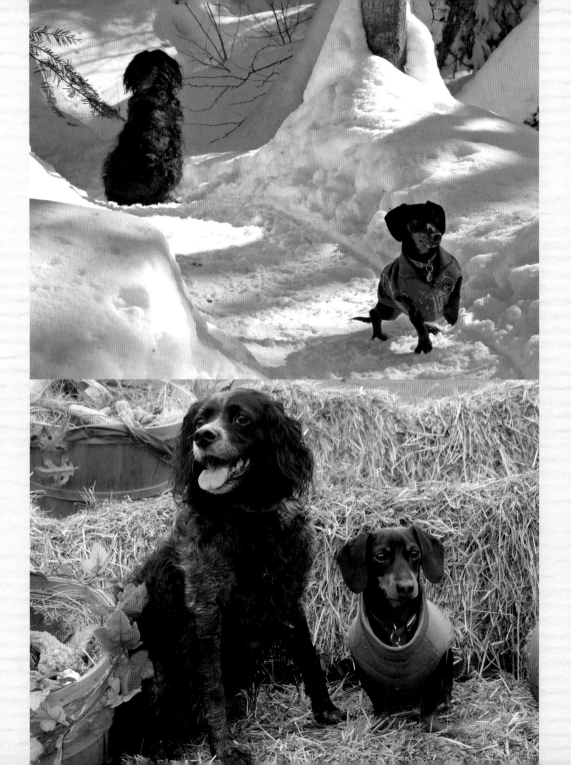

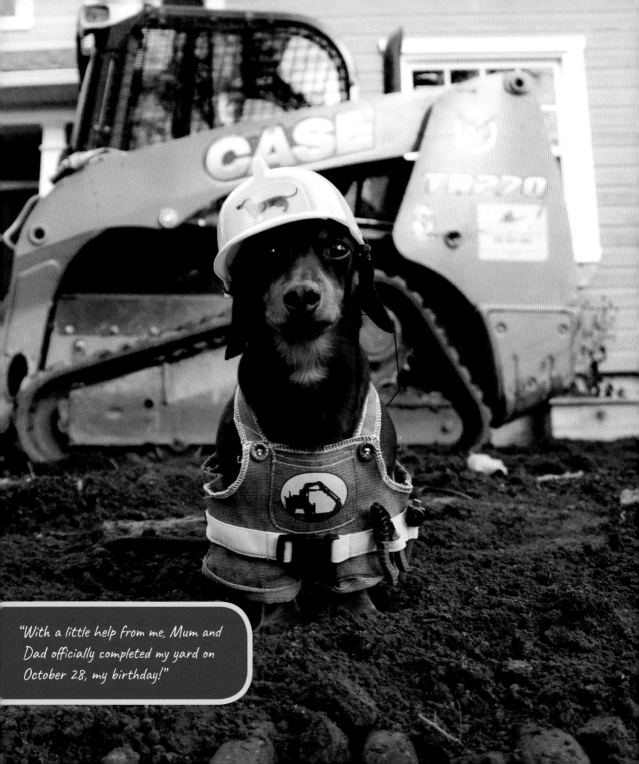

"With a little help from me, Mum and Dad officially completed my yard on October 28, my birthday!"

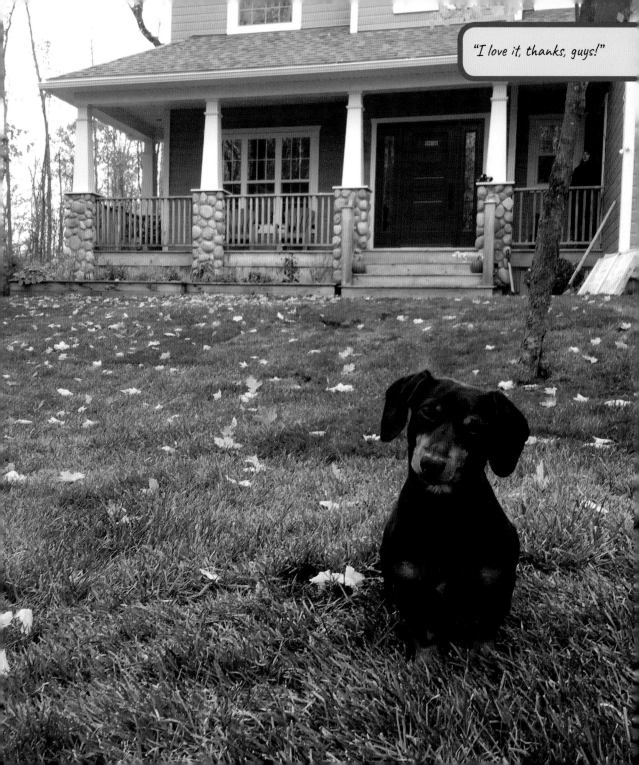

Banff National Park,
–
Alberta, Canada

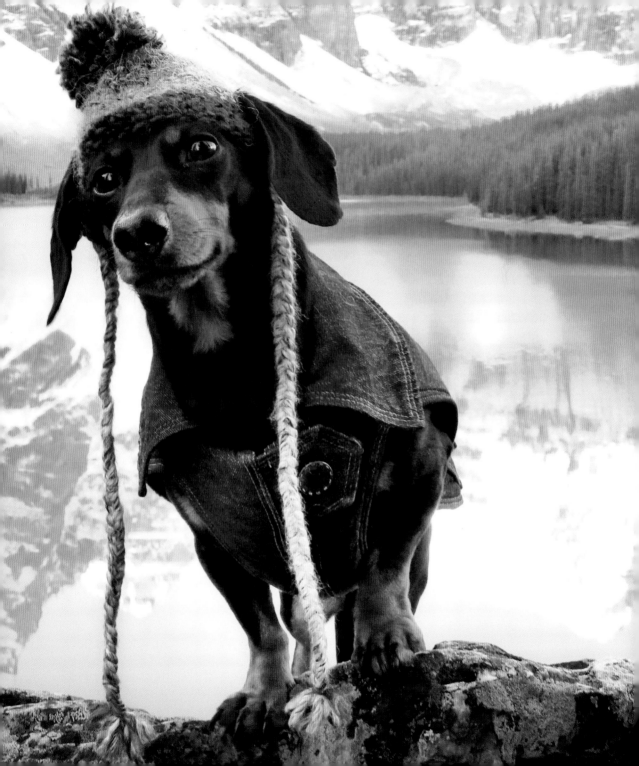

After my surgery two months ago and a long rehabilitation routine, it was nice to finally receive the "OK" from the doc to be a normal dog again.

So, what better way to celebrate, and to honor Laffie's legacy, than with a little trip to the wilderness! How about Banff National Park in the Canadian Rockies, Canada's first-ever national park? This is about as wild as it gets!

As we entered the Banff park, we passed this wildlife crossing sign by the side of the road. I was thrilled at the thought of seeing one of those creatures, so I insisted we pull over, whipped out my camera and held it at the ready!

Several minutes went by . . .

"Dad, when the heck do they start crossing? I don't got all day here!"

But as I, *and many other doofus tourists have discovered,* there's no specific time.

The Bow Valley Parkway is renowned for its wildlife viewing, so early the first morning (and every morning), that's where we headed to start the day.

At the entrance to the parkway, I stopped for a quick pee break. When I hopped back in, I showed Mum my camera and said, "Look, there was a wolf just over by the sign!"

You see, just like how Africa has their "Big 5" animals, so, too, does Banff! The wolf is the first one I've checked off

Wildlife Crossing next 3 km | Passage d'animaux sauvages sur 3 km

ATTENTION

my list, but I especially wanted to see a bear—*from a non-snackable distance of course.*

As we continued our slow cruise down the road with eyes peeled out the windows, I suddenly exclaimed, "Hey, look!"

Another one of the Big 5! The elk!

Or more specifically, a bull elk guarding his harem of ladies.

"Hey Dad, how come you don't have a harem of ladies like that guy? Were you not alpha-enough of a male to win over more than one female?"

Dad looked thoughtful. "No, I definitely was. It's just that *I chose to be* with one. . . ."

At that point I noticed Mum give one of her "looks" in Dad's direction, which indicated it was best if I let them be.

After a short car ride, I had my paws on Rocky Mountain soil for the first time and was leading the way through the woods on a short, easy hike called the Fenland Trail.

Along the way, I couldn't help but take a few minutes to reflect and take it all in; the quiet river flowing by, the soft rustling of trees, the birds chirping and woodpeckers knocking, and Mum's loud,

obnoxious singing meant to warn any nearby bears of our presence. . . .

Laffie would have loved it here, especially considering she was mostly deaf.

A little farther down the pathway, we came across a marshy opening, and I couldn't believe what I saw. Perfectly situated in its natural habitat was the moose. Another check off my list.

They're actually a lot smaller than they look in pictures, but are quite dangerous and territorial.

Next up was the gorgeous Lake Louise. The pristine mountain waters give this lake a mesmerizing turquoise color. Incredibly, the colors of my toque perfectly matched my mountain backdrop.

Heck, it looks like we walked straight into a postcard.

From the lake, we decided to embark on the longest hike of the trip, which went up the mountain to the Lake Agnes Tea House.

Before my surgery, I would have been able to do this hike no problem, but since I'm still working back up to that level, Dad carried me most of the way, only putting me down for short 5-minute intervals when I wanted.

As we climbed higher, the endless landscape of mountain summits came into misty view, and from within that bouncing sling bag I had a moment of realization. For the first time I understood that I would never get the chance to conquer all those mountaintops, that the world is too big for one wiener dog to conquer it all. Yet, somehow, I had learned to accept that. For it's not always about doing more, going farther, or climbing higher. Sometimes it's about where you are, looking out from the peak on which you stand to appreciate the world around you and the people beside you.

Thinking on this enlightenment, I was quiet for most of the hike up until we finally reached the lovely little teahouse overlooking another enchanting lake.

Tuna sandwich and soup, don't mind if I do! All this contemplating the meaning of life had me famished.

On our way back to the hotel, along the Bow Valley Parkway once again, we finally saw what I was after. Just off in the field was a grizzly, grazing away!

I rolled down my window and yelled, "Hey bear, how's the salad bar?! Haha. I bet you could go for a hot dog, huh? Well, you ain't getting' this one, *sucker*!"

"Don't tease the bear!" Mum scolded.

Of course, you shouldn't tease bears, but do you know which animal causes the most injuries in the park? Not the bear. And not the ferocious Wienerwolf, surprisingly.

Nope. Can you believe it's the frickin' squirrel?? Ridiculous, I know. But once again those doofus tourists like to try to feed them (against park rules), which often leads to the squirrel chomping on a finger! So, how about you leave the squirrels to us wiener dogs? 🙂

Technically, the deer would be the fifth animal on my list, but "man-eater squirrel" sounds much more bad***.

 Keep waitin',
Crusoe

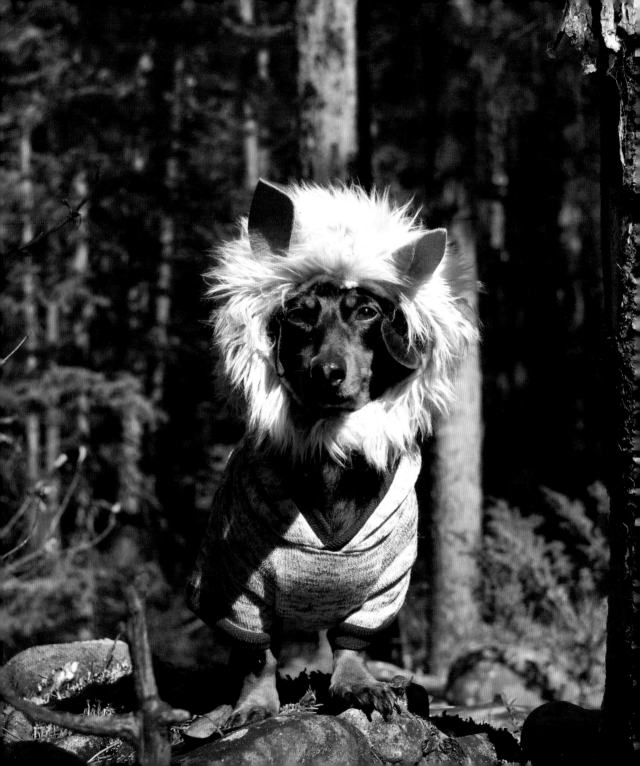

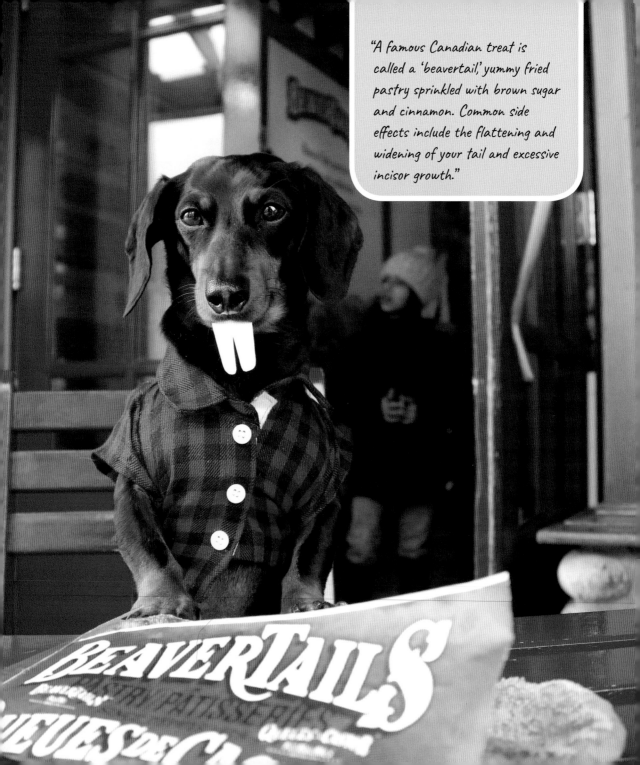

"A famous Canadian treat is called a 'beavertail,' yummy fried pastry sprinkled with brown sugar and cinnamon. Common side effects include the flattening and widening of your tail and excessive incisor growth."

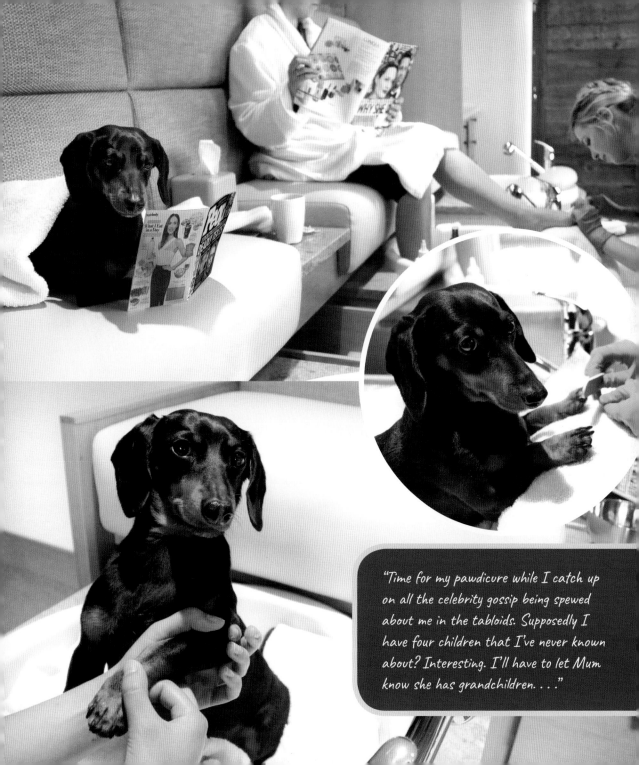

"Time for my pawdicure while I catch up on all the celebrity gossip being spewed about me in the tabloids. Supposedly I have four children that I've never known about? Interesting. I'll have to let Mum know she has grandchildren...."

"We're really into skiiing—mainly
for the apres ski drinks and
the cookies, though."

New Orleans,
Louisiana, USA

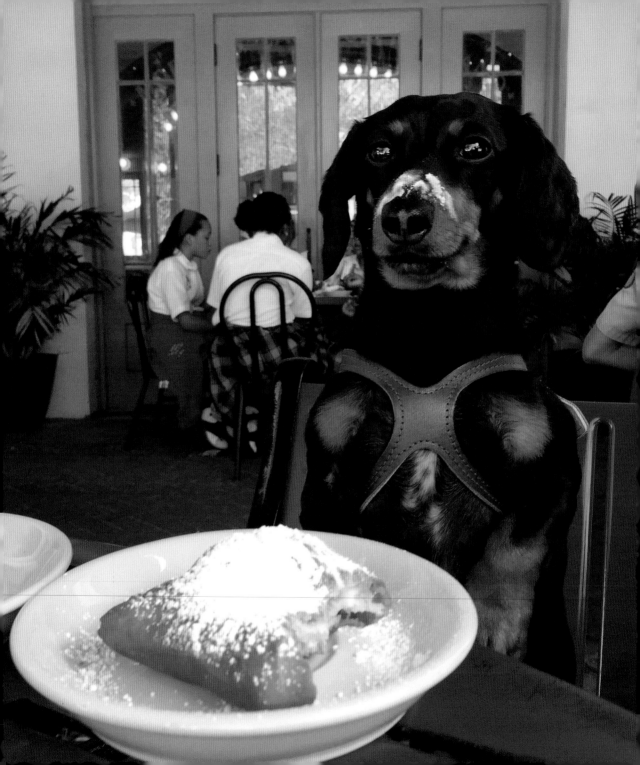

NEW ORLEANS ARRIVED

It was just a personal vacation choice that we decided to visit New Orleans; a city where vibrant Spanish architecture coupled with French descendants and new American influences combine to make it unlike any other place in the world.

The very first thing we did was to try one of their famous "beignets" at the equally famous Cafe du Monde.

I don't know what the heck kind of service they offer though, because this beignet was served to Mum with two huge bites already taken out of it! I've never seen anything like it in my life!

So, the next time the waiter came around, I politely stopped him and said, *"Excusez-moi, Monsieur,* it seems my Mum's beignet has been in someone else's *bouche* on its way over here. She would like a replacement, *s'il vous plaît.*

The waiter gave me a funky look, and said, "Right away, *Monsieur,"* but not before handing me a napkin.

In front of the café, a local saxophone player was entertaining the guests with his jazzy tunes. I also noticed people were giving him money for it! So, I figured I'd join him for a couple minutes and it'll pay for my beignet!

Luckily, Mum always carries my saxophone in her purse for such occasions.

While down in the historic district, we decided to walk around, which is where I came across a Paw Reader!

I've never had my paw read before so I had to give it a try!

The reader looked long and hard at my little footsie. "I see you just went through a difficult time. . . ."

"Yes, yes," I replied. "I just had surgery. All better now though! I assume my future must hold many rewards for me?!"

"Well, I'm predicting you will have many . . ." she said, stalling.

"Many what?!" I demanded eagerly. "Squirrels? Squeaky balls? Swooning ladies? *Statues??*"

"Ah, I see it now!" she said. "You will have many baths, because the streets here in New Orleans are disgustingly dirty. . . ."

Argh!

For our week there, we pretty much did everything all the New Orleans tourists do. Eat, drink, walk around, and eat some more.

I visited The Bulldog beer tavern for some tasty local brews. . . .

Had a hot dog at Dat Dog . . .

Was a *naughty dog* on Bourbon Street . . .

And was a *regular* dog in the beautiful City Park, which is where I happened upon a particularly enticing squirrel. . . .

"What sort of toilet water do you have on tap today?"

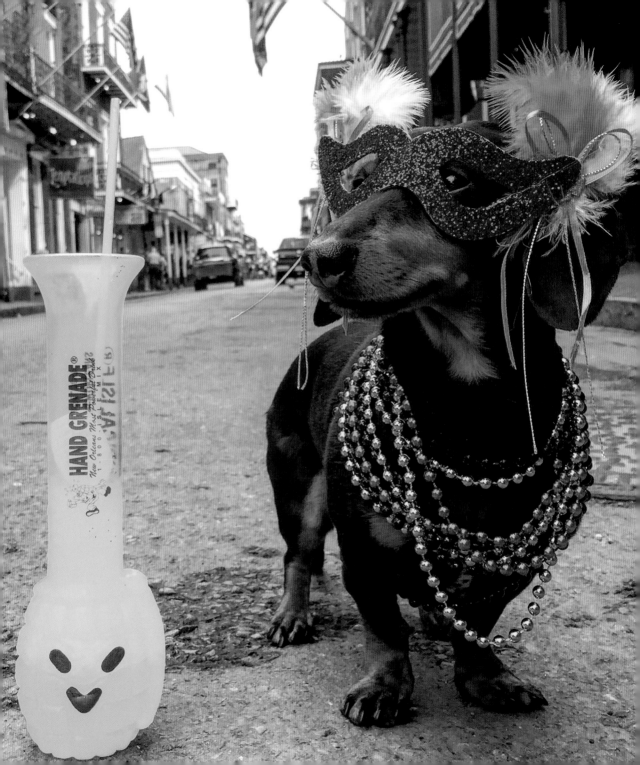

In fact, I don't think I've even chased a squirrel since my surgery!

Now, visiting a cemetery would not generally be high on my list, but it's something New Orleans is especially known for, and with many ghost tales to boot!

I was a little apprehensive, but especially so when I discovered this cemetery of St. Roch is known for the ghost of a dog; all-black and unnaturally large who wanders among the tombstones at night.

As our guide went on to explain why their cemeteries use above-ground tombs (vaults) as opposed to burying their dead (you don't want to know why!), I snuck off while everyone else wasn't paying attention.

When they were least expecting it, I jumped out at them with a ghostly bark as the St. Roch ghost dog!

The gang of them fell backward over themselves in terror. Dad almost died of fright, and Mum nearly had a heart attack from the fact I had cut up the curtains from our Airbnb rental.

Now I know what you're thinking, swamps and wiener dogs don't mix, but you should know I am not scared

"'Boof!' That's a boo and woof together."

of anything except vacuum cleaners, cabbage, and poor fashionwear. THOSE are scary.

Despite the guide assuring us there was no danger of a gator attacking our kayak, Dad kept me close.

I must say though, for such an unappealing name as "swamp," there is an understated beauty to this place.

Maybe I've been watching too much southern reality TV, but I felt I had to try my paw at gator huntin'.

"See any down there, Ma?"

That's when a big sucker swam right under the kayak.

Pow pow

I got him! He weighed a whopping 250 pounds by my estimation, but with the added strength of my Wolverine bones, I yanked him right out of the water as if he were a little plush toy.

"We're going to be squeakin' good tonight!" I told everyone.

Keep spookin',
Crusoe

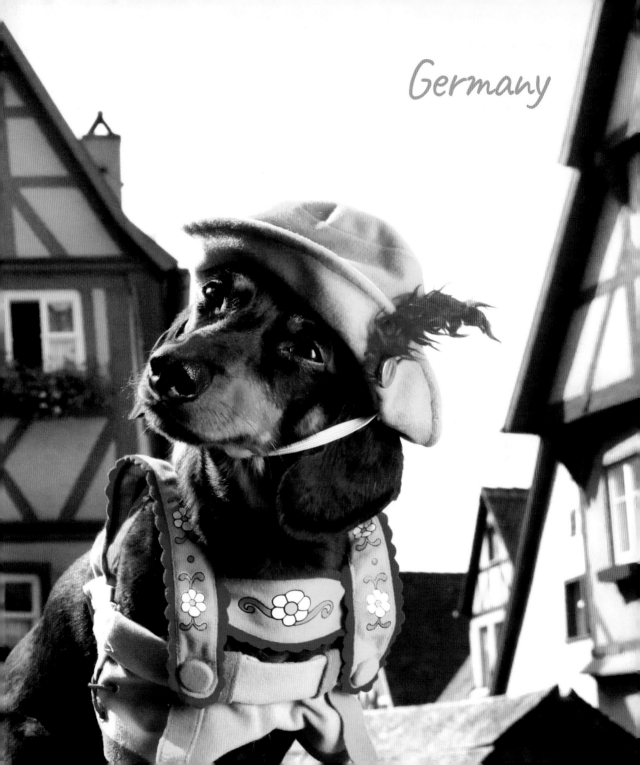

Germany

I was so excited—my ancestral homeland; of course, dachshund meaning "badger dog" in German. However, I was also a bit apprehensive as I've heard there are many wire haired dachshunds here. If you know me, you know I've had some trust issues with them.

We arrived in Frankfurt, from where we headed straight to Rothenburg ob der Tauber, a picturesque little village well known for being one of the best preserved medieval walled cities.

However, before arriving I did a bit of quick internet research that revealed that everyone here wears lederhosen, so that was the only type of clothes I packed.

Unfortunately, as it turns out, most people wear regular clothes. Talk about a doofus tourist . . .

In the picture from the start of this chapter, I am sitting at the Plönlein Corner, one of the most iconic picture ops in this town, region, and sometimes, all of Germany! In fact, the guidebook Mum refers to for Germany features a photo of this same scene on the cover.

One of the very first things I had to do was try an authentic German beer. It had barely touched my chops when I was telling Dad to *order me another one!*

I wasn't sure if it was because of all the beer I was drinking or just because I'm a wiener, or some

combination of both, but some soldiers subsequently came and arrested me with charges of disorderly conduct and indecent exposure.

They threw me in the stocks for 24 hours.

I knew this town was medieval, but I didn't realize it was quite *this much*! Luckily, I was able to slip out of that thing quite easily as soon as they turned away.

One of the most interesting features of Rothenburg is that you can walk along the ramparts of the original medieval wall, peering through the same arrow slits that soldiers once used to defend this town with their bows and other weapons.

"Come on lads, we must defend the wall! Draw thy sword and bare thy teeth, the wire haired horde is attacking again!"

That's when my cell phone started

ringing from underneath my armor, throwing me out of character.

It was a fan in Berlin, who happened to work as the editor for *Fuhrstuckfensumthin*—essentially, Germany's (and actually Europe's) most-watched morning show. They wanted to fly me over to be on the show, which would also give me an opportunity to explore Berlin!

So, before I knew it, there I was, tromping around the German capital!

Here I am posing at the wall; what's so special about it I didn't know; we have plenty of graffiti-covered walls back home, too!

I also had to try the Wiener schnitzel I had heard so much about. I was expecting it to be some type of sausage (hence the "wiener"), yet, it was completely flat.

With bellies full, we marched onward with our Berlin explorations, down tight sidewalks and busy street corners. Mum always made sure to keep me on a short leash, even picking me up when needed (so I didn't get schnitzel'ed of course).

We soon found ourselves at the Reichstag, their house of parliament.

With so many tourists around, Dad warned me to, "Keep watch for pickpockets."

Which is exactly why I wore my fanny pack and kept a close eye out for wire haired dachshunds. Statistically, they represent about 100% of all pickpockets.

Thankfully, none of our belongings went missing.

After my interview the next morning, I

"So, this is what happens to wieners when they get schnitzel'ed. . . ."

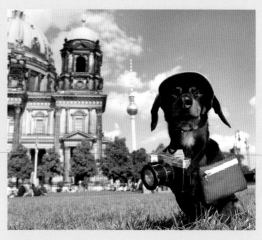

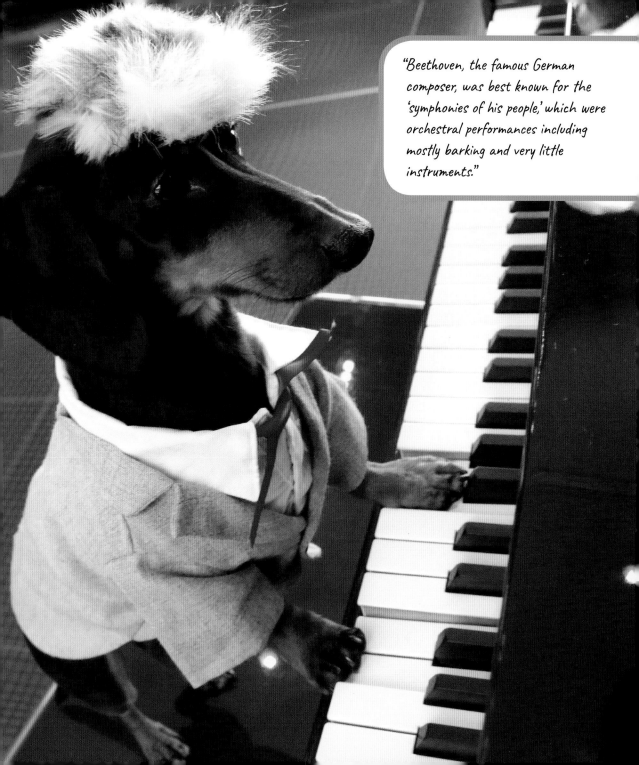

"Beethoven, the famous German composer, was best known for the 'symphonies of his people,' which were orchestral performances including mostly barking and very little instruments."

bade my farewell to the editor who had invited us with a fat smooch upside the kisser.

Then we were off to Baden-Baden to spend the rest of our stay in the ominous-sounding Black Forest.

This is a place for the rich and famous, a longtime aristocratic playground that attracts the wealthiest Germans, Russians, and Arabs, who come for its renowned spas and gambling.

It's safe to say this town is a little pretentious and full of itself, and therefore, also safe to say I fit in just fine.

It was quite pretty, though, with beautiful hotels, gardens, and a lovely green promenade along a cobblestone streambed with flower-adorned bridges arching across it.

Since it was quite hot, the shallow stream was the perfect refreshment.

Yet, the end goal of our walk (as planned by Mum) was the Café König where they serve up their famous Black Forest cake! *Mmm . . .*

"Perfectly camouflaged as a black dog in a Black Forest. The squirrels here don't stand a chance!"

In fact, the cake alone was pretty much why Mum wanted to come to the Black Forest!

While driving around the cute little villages, we noticed one house in particular looked a little different. . . . As it happens, it wasn't a house but a giant cuckoo clock, with the mechanized wooden cogwheels and everything *inside*!

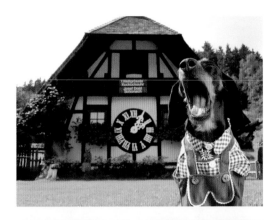

When I saw the time, I couldn't help but yawn. It was way past my naptime.

"We should buy a cuckoo clock!" Mum said afterward, to which Dad agreed. So, we went to visit the factory itself where you can find the best prices.

I don't know how anyone could ever decide which clock to buy, though. All that clicking, ticking, cuckoo'ing, clucking, and thinking had my head spinning!

"I think I'll stick to a simpler sort of souvenir," I said, not even realizing my own pun.

Back in Baden-Baden, I had to get a taste of the high life I kept seeing all around me. So over to the casino we went, the most bedazzling, high-class establishment I've ever laid eyes on.

I couldn't show up by myself though, so I found a local girl named Doggi on

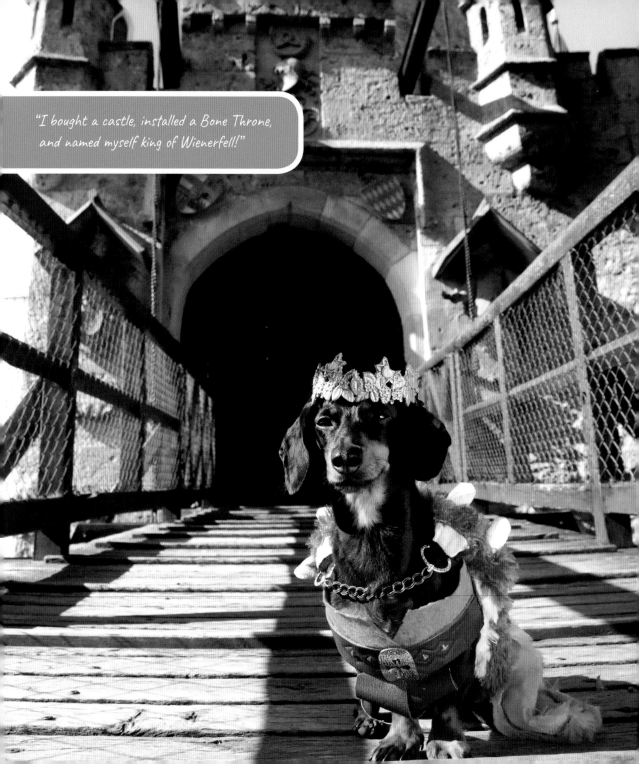

"I bought a castle, installed a Bone Throne, and named myself king of Wienerfell!"

a casual dating website to join me for the evening. Her profile photo must have been from like 20 years ago though, because she looked *just a tad bit older* than her picture. . . .

Not that that was a problem. I love all kinds of ladies.

"How about some roulette?" I asked, in my manliest 007-esque voice. She made a peep noise that I assumed to be a *yes*.

We hopped up onto the table, and I introduced myself to the dealer. "Name's Dog, James Dog." Then I turned to the nearby server, "And I'll take a toilet water martini, swirled, not flushed."

Turning back to the dealer, I said, "15,000 euros on number 17. My lucky number, not to mention the age of my beautiful lady friend here."

The wheel spun, which was hypnotic in the way the ball went around and around.

Click The ball dropped. It was number 17. I won, I couldn't believe it! Poor Doggi couldn't see or hear very well, so in a moment of selfishness, I didn't tell her.

"Oh darn!" I said aloud.

Just in time to celebrate my win, my martini arrived, swirled to perfection with a hot dog slice for garnish.

With luck on my side, I was smart enough to know to cash out, so we headed over to the cashier. I pushed my massive stack of 5,000 euro chips over to him.

"Will you be taking cash or cookies?" the man asked.

"Cookies of course," I said, and he began counting them out. It took a while, but by this time my good sense had come back to me, and I decided to split the win with Doggi. She was so surprised we won, but because of her dentures she couldn't eat hard cookies anyway.

Dad, however, was upset when he found out I didn't take the cash, so we decided to use the cookies to gamble some more at the famous race track, where jockeys, horses, and fancy hat people come from all over the world to watch the spectacle.

The race track welcomed me as their VIP guest for the day—probably because they noticed my pockets bulging with so many hard biscuits.

As we each looked over the horse names and their odds, I told Dad to write in the horse name of "Crusoe" on his betting card for the upcoming race. Then I slipped away.

As the next race began, the announcer could be heard over the speaker system saying:

And they're off! SeaStar is out in front with a strong start, but Daisy is catching up quickly—and oh wait, what is this? We have a new horse closing in quick from far behind . . . now he's upon them . . . now in the pack, and oh my, he's taken the lead. Just got word this horse's name is Crusoe!

And to the finish line, in the clear lead, yes, it's Crusoe!

I rejoined Mum and Dad. "Wow, did you see that? I just had a feeling about that horse!"

"Yes . . ." Mum said, slyly looking at me from the corner of her eye. "That horse did look strangely familiar, wouldn't you say?"

"Familiar in that he's a sexy beast of a stallion and lightning fast, yes," I said coolly, as I collected my haul of ever-more cookies.

The final event to mark the end of my trip to Germany was a meetup with my fans in Frankfurt. By this time, I was feeling as German as a German dog

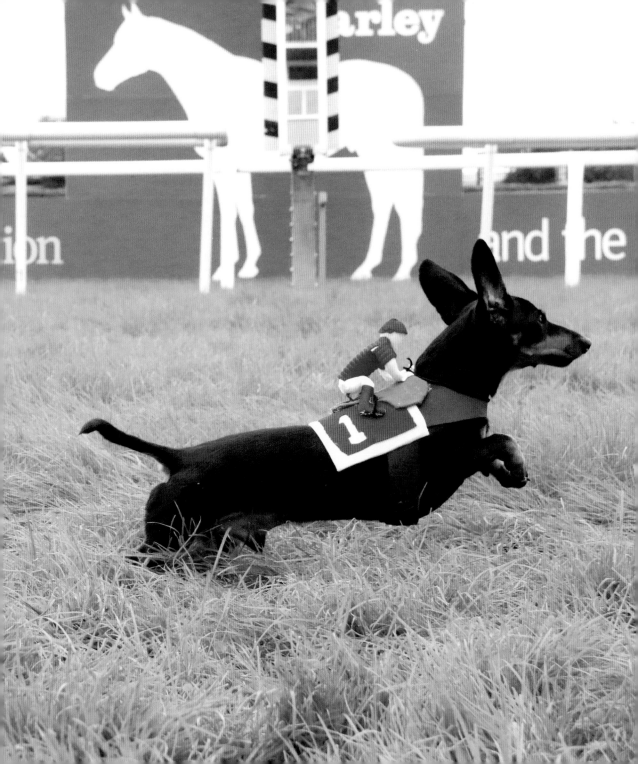

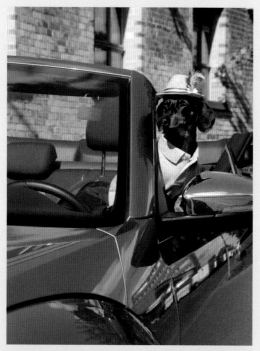

can get, so I pulled up to the event in a Volkswagen convertible, clad with matching feathered alpine hat and all.

There were people from all around; Germany, Switzerland, Holland, tourists visiting from abroad, and Americans from the military bases. One guy even came up to me and handed me his card and a U.S. Secret Service pin and said, "I saw your James Bond video. If you're ever looking to change profession, give me a call," and then quickly disappeared back into the crowd before I even had a chance to reply.

Whether or not I subsequently gave him a call, I can't tell you. Super-friendly guy though, very chatty.

The excitement of the meetup was dampened by the fact that there were a few wire haired dachshunds sleuthing about, which could mean trouble. I decided to set a bit of a trap to test their trustworthiness once and for all. So, I filled my fanny pack with some of my cookie winnings and placed it on the ground behind me.

While in the midst of taking photos with a nice family, I turned my head to see one of the most wiry weasels I'd ever seen nose deep in my fanny pack!

Ryan Beauchesne

"Well, well," I said, catching the thief red-handed. "Why am I not surprised?"

"Oh, Crusoe!" she stuttered with surprise. She was a woman, as I noticed by her voice (otherwise with that beard and those eyebrows I would have figured her for a scraggly old man).

"Oh, what? You thought you could steal my hard-won cookies did you?!"

"*Actually,*" she said before I could continue berating her. "I wasn't stealing your cookies. I was going to leave my phone number in there in the hopes you'd give me a call. I think . . . *I think, you're cute.*"

I was so taken aback I didn't even know what to say.

"So . . . you weren't trying to steal my stuff?" I asked skeptically. "Not even attempting to borrow something without permission? Maybe just trying to rearrange my belongings? *Or perhaps you were going to prank me with one of your poop bags in there?*"

"No, I just wanted to give you my number!"

Then it hit me. "Aha! I know, you were going to give me the number of a criminal organization that would subsequently implicate me once I called it!"

"No, it's mine, I swear! Try calling it!"

So, I did, and guess what? Her wiry caboose started vibrating with a muted buzzing sound. It appeared she was telling the truth. A moment of regret and realization came over me.

"So, you think I'm cute?" I asked, and with that, I invited her to chat over a cup of coffee, but not before discreetly telling Mum to call off the *Polizei* who were already on route.

"What is your name?" I asked.

"Heidi," she replied. I'll admit, she wasn't my typical type—being wire haired and all, but she had a certain charm about her. She then continued in her cute Bavarian accent, "Did you know I went to the groomer yesterday so I could look nice for meeting you?"

"Really?" I was legitimately shocked. "Never would have guessed . . . I actually thought you just stepped out of a dryer or something," I said, instantly regretting it.

"Yes," she laughed, "we do have a certain look about us," and with that she gave a puff of air that hefted her long eyebrows away from her eyes, and in that moment, I saw beyond her wiry exterior for the first time.

Her eyes were a beautiful hazelnutty brown, and I instantly complimented her.

She smiled, and her eyebrows flopped back over. I smiled, too.

It was then that she very gently nibbled at the pretzel we were sharing, barely eating even a mouthful. I couldn't believe it. This was the first time in my life that my date didn't scarf down her food in front of me. It was . . . *refreshing.*

Yet, my time with her was waning, even though a part of me wanted to stay and get to know her more. We bade our last farewells from across the table. I was never open to the idea of falling for a wire haired girl before, but she had opened my eyes—even though I hardly ever saw hers.

I still have her number, though. Perhaps I'll give her a call sometime, depending how things turn out with Paisley, and if Dad's not too cheap to cover the calling fees.

Keep lovin',
Crusoe

Ryan Beauchesne

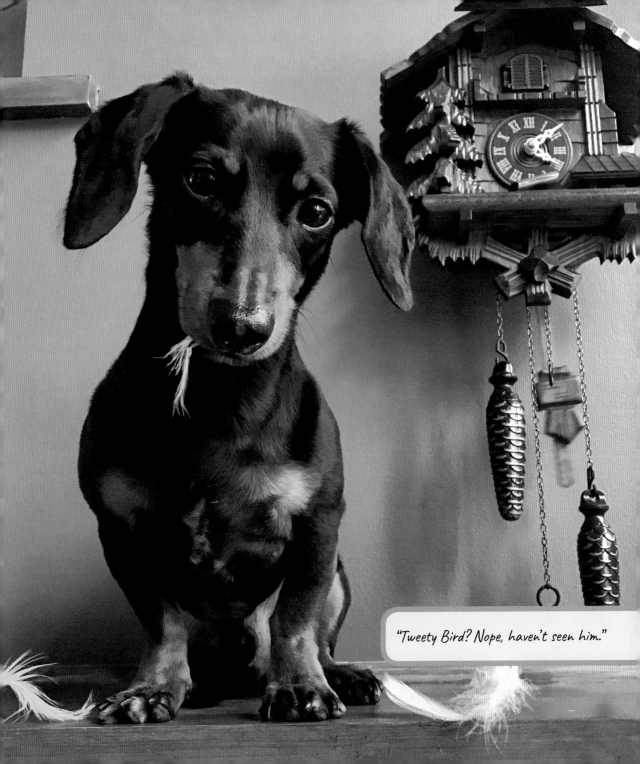

"Tweety Bird? Nope, haven't seen him."

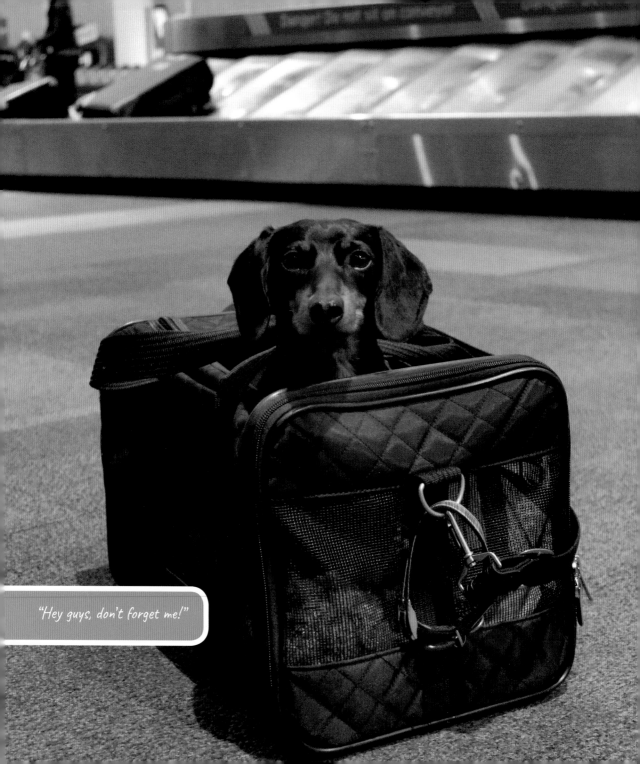

"Hey guys, don't forget me!"

Rededication

After going through the process of writing this book, I would like to rescind my earlier dedication.

My new and official dedication is to my beautiful Mum . . .

for her patience, love, devotion, kindness, for her kisses, even when I don't totally appreciate them, but mostly for feeding me on time every day.

Afterword, by Dad

The past couple years have been nothing less than an adventure for our little family. We never would have guessed that Crusoe would captivate the eyes of so many, or that we'd be traveling and exploring such amazing places with us *by his side,* or that we'd witness lines of hundreds of people waiting hours just to meet OUR little dog. I still pinch myself.

It's all about him, though. If one person out of 700 asks for a photo with my girlfriend and me, we're lucky. Yet, we don't mind. We're both very laid-back, quiet, and introverted people; the type to stay behind the camera, not in front of it. That was the case anyway, until we started getting requests for media interviews and appearances. Since Crusoe doesn't talk in public, I had to fill in for him, and boy, was that a personal development story for myself! I like to think I'm passable on camera now, but I'll never be as photogenic as he is. I still remember one morning we came in for an interview on Breakfast Television. We arrived in the back room where they put me into makeup right away. Once done, we sat together, waiting for our call to go on, when the producer came in to check on us. She took one look at me and said, "This guy needs to get into makeup."

So now, Crusoe always jokes that I need at least two coats of makeup to be presentable. Three is best.

Crusoe is like our 3-year-old son who

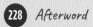

"This better be some kind of joke. . . ."

never grows up—with all the whimsy, comedy, and mischief to match! My girlfriend and I both work from home, and we're with him almost 24/7. We bring him with us everywhere we go, whether down the street or overseas. We would do anything for him, which is why his surgery was such a rough time for us, and why seeing him get older is a sobering reality. Yet, as Crusoe and all dogs teach us, life is full of adventure, love, and playfulness. He doesn't care that he had surgery, or that he has more gray hairs coming in, or that his perspective is only fourteen inches off the ground. He's just happy to be here today, with us, and having fun.

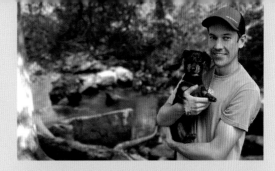

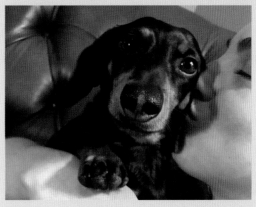

On top of being a beloved member of our family, Crusoe is also very special in that he's blessed me with my career for the past couple years. People always say your job should be to do what you love, and well, mine has been to spend time with my dog. I know it won't last forever, but I know I'll always appreciate these special years I've shared with him.

And yet over the course of this time, I've begun to feel like he isn't just OUR dog anymore. The love and generosity we've received from fans across the world, especially in Crusoe's harder times, has shown us there are people out there who care about him almost as much as we do. It's remarkable that we can share the joy Crusoe gives us with so many other people to enjoy as well. It's our fans that we must thank the most. They have made all of this possible.

Enjoy every adventure, travel as much as you can, play with your dog every day, *don't feel the need to Instagram every picture*, but do appreciate every kiss from the ones you love.

—Keep livin',
 Dad (& Mum)

Acknowledgments

Thanks to my fans. First and foremost, they are amazing, supportive, passionate, and dedicated. They deserve so much of my appreciation.

Thanks to my extended family members—Uncle Jack, Carole, Eileen, Dennis, Charles, Cameron, Calvin, my cousins, and others—for looking after me when needed, for all their background roles in my videos and photo shoots, and for bragging to their friends that they have me in their family.

Thanks to my editor Daniela and all my other business partners who have always seen and encouraged my potential.

Thanks to my Mum for all the reasons I've already given, and for just being the best mom a pup could ask for.

And finally, thanks to my Dad for his patience, perseverance, and resolve in helping me get through my surgery and rehabilitation, as well as everything else he already knows I'm thankful for.

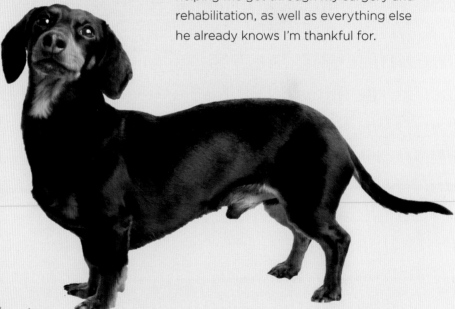